IMAGES
of America

OAKLAND

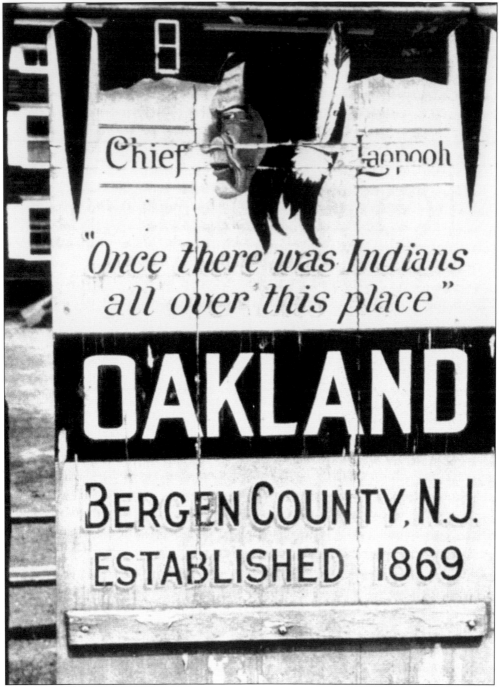

Chief Laopooh

"Once there was Indians all over this place"

OAKLAND

BERGEN COUNTY, N.J. ESTABLISHED 1869

This sign was proudly displayed on the grounds of the Oakland Military Academy on Ramapo Valley Road. While it is accurate that "Once there was Indians all over this place," here in Oakland, no photographs of them survive. The depiction of the fierce Chief Laopooh belies the fact that the local Native Americans were known as the "tribe of old women" by members of their fellow Indian nations, due to their peaceful nature. Unfortunately, the sign also did little to illustrate the grammatical capabilities of Oakland residents.

IMAGES
of America
OAKLAND

John Madden and Kevin Heffernan

ARCADIA

Copyright © 2003 by John Madden and Kevin Heffernan
ISBN 0-7385-1301-6

First published 2003
Reprinted 2004

Published by Arcadia Publishing,
an imprint of Tempus Publishing Inc.
Portsmouth NH, Charleston SC, Chicago,
San Francisco

Printed in Great Britain

Library of Congress Catalog Card Number: 2003107450

For all general information, contact Arcadia Publishing:
Telephone 843-853-2070
Fax 843-853-0044
E-mail sales@arcadiapublishing.com
For customer service and orders:
Toll-free 1-888-313-2665

Visit us on the Internet at www.arcadiapublishing.com

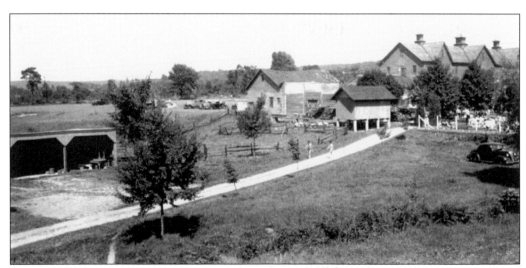

Pictured above is Mullers Dairy Farm in the 1930s. It was located in the southern portion of Oakland near the Doty Bridge. Ultimately, it became a resort and swimming facility.

CONTENTS

ACKNOWLEDGMENTS

The endeavor to write this book began innocently over a few beers in the Valley Pub, in Oakland, in February 2003. We had only a few photographs, and we knew little about the magnitude of this project and even less of our need for so much assistance. However, we had a lot of help, as so many people contributed photographs, postcards, and memories as invaluable records of Oakland's past. The contributors brought many pictures to life, changing what otherwise would have been a sterile reporting into an often-charming anecdotal history of the scene.

Our first words of appreciation go to our wives, Jane Madden and Linda Heffernan. They are saints for putting up with us under normal circumstances, and they were near martyrs during the months that it took us to complete this work. Without their support there would be no book. Thank you both.

We owe a huge debt of gratitude to the many listed here in alphabetical order. Equally, we extend our apologies and thanks to those whose names we may have unintentionally failed to acknowledge below. Thanks to all for your help.

The bartenders and waitresses at Hansel's, Gordon's Place, and the Valley Pub for their points of view, memories, and help in the selection of the cover photograph.

Hank Bitten for providing a CD of the Valley of Ponds prepared for Indian Hills High School.

Brendan Cornwell, our designer at Arcadia, for answering our often silly technical questions with calm and aplomb.

Chris and Ann Curran, the real Oakland historians (who now live in Vermont), for the old postcards, corrections, and encouragement.

Ann DiLorenzo, a font of old Oakland information and trivia, for the loan of her postcard collection, photograph collection, and recollections.

Ed Feiszli, a master carpenter, restorer of the Stream House, and virtual biographer of the Page Estate, for the pictures of the Page Estate and farm.

Judy Gray, president of the Oakland Historical Society, for making the extensive files of the society available and for baby-sitting us while we scanned hundreds of old photographs.

Susie Jaggard and Pam O'Neil, our intrepid editors at Arcadia, for their encouragement and help and for putting up with us.

Frank Leone, Oakland's revered postmaster, for sharing his memories, being a friend, and making his photograph collection available to us.

James O'Connor, the Oakland police chief, for the history of the Oakland Police Department and the gems from his recollection.

Helen Otto, the owner of Otto's Floral Manor and a wonderful lady, for your recollections and early pictures.

Al and Doris Sanders, wonderful neighbors and lifelong residents of Oakland, for offering many old Oakland photographs, sharing their memories, and filling in so many historic blanks.

Richard Whitby, a newspaper editor, for keeping us out of jail with his priceless advice on copyright law and for his generous offer for bail.

INTRODUCTION

On April 26, 1902, our community, then dubbed Oakland Station by the railroad, separated from Franklin Township to form a separate town with the approval of Bill No. 43 in Trenton. Why?

One reason was taxation without representation. The refusal of the Wyckoff section to permit Oakland representation on the school board and its denial of a better school in Oakland lit the fire of succession. Additional reasons were sharply provided in an anonymous letter to the editor of the *Oakland News*, dated March 27, 1902, and signed "An Effected Taxpayer."

"What a shame that our little village should be subjected to such treatment at the hands of a selfish majority. The legislature realized that our taxes were not being used to give us improvement; that our vote could not be properly polled; that the supposed macadamizing of our roads was nothing more than the scattering and rolling down of a few stones; realized that in fact we were being imposed upon."

While this book presents Oakland's past from the late 1800s to c. 1960, it also recognizes the forces that led to the transformation of Oakland to the present.

One is economic. Oakland was a self-sufficient farming community in 1902. However, Oakland farmers were subject to many of the same socioeconomic pressures as exist today. Farm incomes declined while taxes increased, leaving farmers' inheritors little economic choice and significant economic incentive to yield to progress.

Another is fire. "Well, it burned down," was the refrain heard during the many inquiries made concerning "lost" Oakland buildings. In 1902, buildings were heated with coal and wood, and most cooking was done on wood-burning stoves. Prior to August 1, 1916, when electricity came to Oakland, homes were lighted by kerosene or gas lanterns. Building and fire codes were nonexistent. One unattended spark could forever remove another piece of Oakland's heritage.

Development in Bergen County spread east to west from New York City during the 20th century. Oakland, the farthest from New York City in the county, was among the last to change, and then, it changed most significantly. Many photographs in this book are of buildings, mostly of homes that existed on Ramapo Valley Road, then known as Main Street. Collectively, these could rival the finest Victorian street scene now in Cape May.

Until 1960, Oakland enjoyed the reputation of being in the backwaters of Bergen County. Although the railroad brought change in 1869, the arrival of Route 208 in 1963 marked the beginning of the end of a semirural Oakland. Together, they brought notice, access, interest, and people. From the late 19th century to the mid-20th century, Oakland was a resort town, boasting many hotels, picnic areas, and swimming facilities by the Ramapo River. Water from the Vernam Spring was bottled by the Kanouse Bottling Company and sent throughout the region as a health tonic. There was Lilac Manor, the magnificent three-story Victorian home of Remington Vernam, previously the health resort Ramapo Hills Sanatorium. Of these and many more, only the spring remains as testament.

Walk with us now to visit the architectural ghosts of Oakland, with many views that were taken before Ramapo Valley Road was paved, to a time when the river could be seen across the open farm fields from Main Street. A past from the point of its beginning. We hope that you enjoy this journey into Oakland's past.

AUTHORS' COMMENTS

Why this book, why now? Because it is good to remember, even if we were not there, and it is better to appreciate. This record of Oakland's past yearned to be done lest our heritage and pictorial record be perhaps lost to future generations. This book records the change to our community that can only be measured by the distance of years.

In 1952, during the celebration of the 50th anniversary of Oakland, Mayor Arthur W. Vervaet admonished, "History gives a perspective. . . . it imposes a sense of guardianship, of trust, a reason for the proper care of the resources which served our forefathers and must also serve our heirs."

The eloquence of Vervaet spoke to the future generations in the management of change, a guardianship. Since those words were spoken, Oakland has witnessed the greatest change in its history, and as some might suggest, massively disregarded the words of Mayor Vervaet. If you live in Oakland, there is a 99 percent chance that your house sits upon what was virgin farmland 100 years ago and a 75 percent chance that it was farmland as few as 50 years ago. Three-quarters of the homes now in existence here were built between 1950 and 1970, and the transformation today is still in process.

A visitor to Oakland from 100 years ago would certainly be completely lost today. The same could be said of a visitor from 50 years ago. Strip malls and commercial buildings have replaced grand Colonial and Victorian homes. One such development even sits upon a graveyard. With the widening of Ramapo Valley Road and the modernization of the Oakland business district, once-proud Victorian-era stores and homes with shade trees, protective overhangs, and turned posts have morphed into nondescript façades and parking lots. Several of these Victorian buildings still exist, although unrecognizable from their past except to those with a saddened, trained eye.

As we look back, it seems that the instincts for preservation did not really exist then. Unbridled change was viewed by many as good. Away with the old, and bring in the new. However, while we cannot sit in judgment of the past, we can learn and perhaps even act. Many of us have the preservation instincts that resonate as a yearning to preserve the remnants of the past and a longing for the simpler values than might be assessed today, in the early 21st century.

There is no question that Oakland will continue to change. However, every resident of Oakland has a vote in the course of that change. Although we may lament the loss of the character and historic buildings of Oakland over the last century, we know that we cannot bring them back. How will you cast your vote, and what decisions will you make about the physical character of Oakland for the future? Will the citizens of Oakland 100 years from now lament the changes, or will they celebrate the preservation of the remaining architectural treasures within our community?

—John Madden and Kevin Heffernan
March 19, 2003

One

VISTAS, VIEWS, AND MAPS

The record of Oakland's history and growth can be told in many ways. This chapter attempts to capture old Oakland in the form of overviews from old maps, photographs, and postcards presenting views and vistas that no longer exist. It is designed to set the stage for the chapters that follow, which offer a closer look at the people, times, and places. Collectively, these views illustrate the magnitude of change that has come to Oakland since 1861, measured both by what has been added in the form of development and by what has been subtracted to make way for that development. This chapter, therefore, records the change of the status of Oakland from a rural community to one that is becoming an integral part of the New York City metropolis.

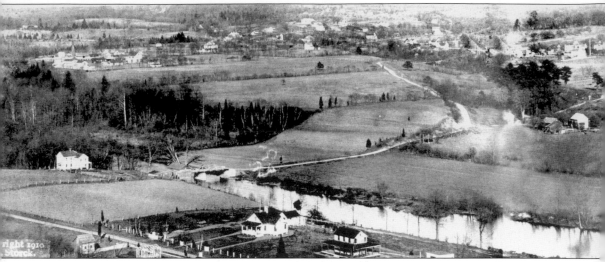

Can you find your street? These two pages and the two following present a rare and marvelous view of Oakland in 1910, when William Taft, who succeeded Theodore Roosevelt in 1909, was president. While seemingly very extensive, the area shown on these pages covers only about 1.25 miles, from roughly the old railroad station to the corner of Long Hill Road. The road winding through the photograph diagonally to the bridge is West Oakland Avenue. The vacant field to the right of the bridge is the future site of the Riverside Rest of the 1920s, which ultimately became the Timbers restaurant of today. Notice the house being built at the bottom of the photograph, with the outhouse being completed first. The group of buildings in the upper left corner is the gunpowder factory, and the Page farm extends into the extreme upper left corner.

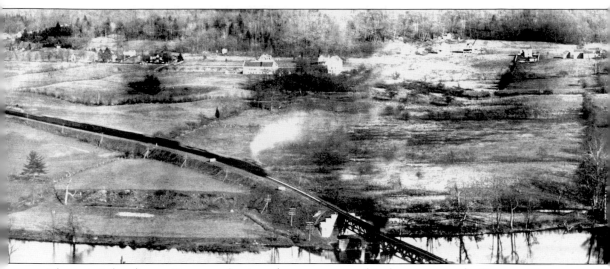

The train is heading to Pompton Station, the next stop, and is about to cross the Ramapo River on a bridge that was rebuilt and elevated after the Flood of 1903. At the top center is the Calderwood Hotel, and to the immediate right is Oakland's new school. To the right of the school is Ivy Hall, which was built in 1880. Roughly in the center is the future home of Oakland's municipal complex.

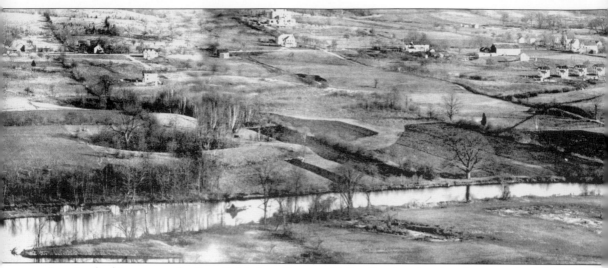

Imagine looking across the farm fields from Ramapo Valley Road and seeing the river. In 1910, you could. The large building in the upper left is the residence of Ludo Wilkins, who owned the Wilkins Brush Company, located at the extreme right on the opposite page. Just past the Wilkins house is the home of John Demarest. The five small houses directly above are said to be houses of key workers at the Wilkins factory. Directly above them is the Lloyd house, the future home of Doris Sanders. The trail running diagonally behind the Wilkins house is now Grove Street.

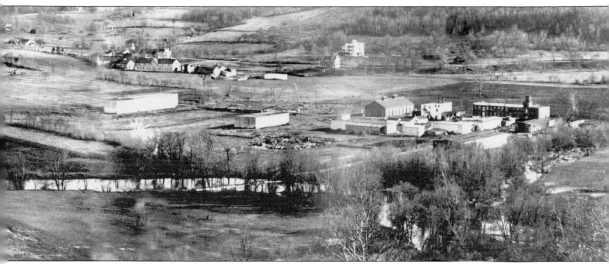

The group of buildings on the right is the Wilkins brush factory complex. Only the large building at the far right remains today. Reported to be an illegal still during Prohibition, the factory again had a legitimate use as part of Mullers Recreational Park. The large Victorian building in the center of this view is Lilac Manor, the home of the Vernam family. In the upper left corner, hardly noticeable, is the 1829 Ponds Church. The field in the extreme upper left corner is the future home of the Oakland Shop Rite.

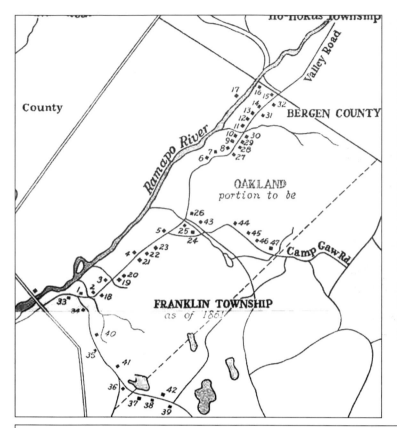

In 1861, Oakland had a total of 40 homes and 7 nonfarming buildings. This rare map, drawn 51 years before Oakland's incorporation as a town and 8 years before the arrival of the railroad, is keyed to show the owners' names of and the locations of every important building in town. Interesting are the cluster of homes near the Hohokus Township (Mahwah) border and the location of the Farmers and Mechanics Hotel there as well.

PROPERTIES OF RESIDENT-OWNERS OF THE OAKLAND PORTION, FRANKLIN TOWNSHIP, BERGEN COUNTY—SURVEY OF 1861.

From the foot of Oakland Avenue and continuing north, on the west side of the road:
1. Ponds Church
2. Graveyard
3. S. P. Demarest
4. J. J. Winter
5. Wm. Van Blarcom

and thence up Valley Road
6. J. P. Ramsey
7. P. C. Bogart
8. J. Fox
9. A. G. Garrison
10. C. Yeomans
11. J. P. Smith
12. Wm. Ackerman
13. G. W. Steel
14. Farmer's and Mechanics Hotel
15. S. D. Bartholf

To left on Midvale Rd.:
(Glen Gray)
16. A. Hopper

and left, down west bank of river,
17. S. J. Fox

*

From foot of Oakland Ave. north, on east side of road:
18. H. L. Spear
19. D. J. Demarest
20. S. D. Demarest
21. Smith shop, J. Mandigo
22. M. Ryerson
23. C. Van Houten
24. Wm. Van Blarcom
25. Saw Mill

Valley Rd. just above Page's Corner:
26. Mrs. H. Van Houten
27. A. G. Garrison
28. J. A. Zabriskie
29. BSS & Wheelwright
30. A. P. Ackerman
31. Wm. P. Van Blarcom
32. A. J. Hopper

From the foot of Long Hill Road, at Oakland Ave., south side of the road:
33. A. Doty
34. Parsonage
35. M. Sterr
36. H. B. Demarest
37. J. Ackerman
38. B. Bartholf
39. W. Ackerman

North side of Long Hill Rd., from foot:
40. J. H. Spear
41. H. Cummings
42. A. Boyd

*

Page's Hill—Camp Gaw Road, north side:
43. C. Bellmer
44. J. Wykoff
45. H. B. Winters
46. J. Post
47. T. C. Post

This is the key to the 1861 map of Oakland identifying the names of the home and farm owners of the time. Although it lists a total of 40 family names, only 21 different families are represented. Of these 21 families, 10 owned the majority of homes in the valley. With some notable exceptions, the family groups tended to live very close to each other. One has to wonder if family feuds might have created the exceptions.

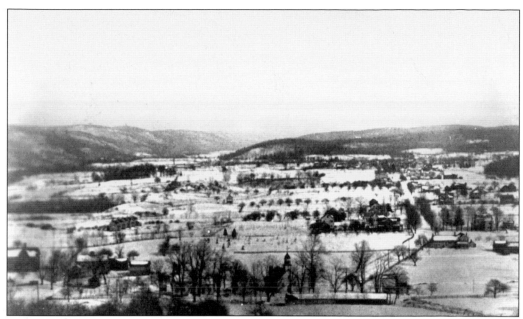

Is this a winter day in rural Vermont? No, this photograph, a partial view of Oakland looking north, was taken between 1910 and 1920 from the hill behind the present Oakland Shop Rite. The Ponds Church is in the foreground, on the corner of Ramapo Valley Road and Long Hill Road (off to the lower right). The first house set back on the left is the Spear house, and across from it is the Lloyd house. Farther up the road on the left is Ivy Hall. The worker houses for the Wilkens brush factory can be seen in the left center. In the lower right corner is the John Post property, which is currently Otto's Floral Manor.

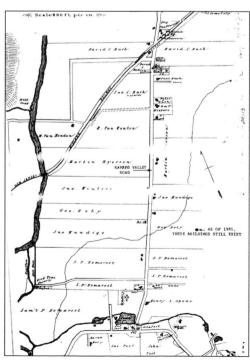

It would be difficult to get lost in Oakland, as illustrated by this 1876 map. However, anyone who was lost could just ask directions from one of the nine farmers who owned virtually the entire center of Oakland at the time. Diagonally crossing the top of the map is the railroad. In the top center and extending to the bottom of the map is Ramapo Valley Road, then known as Main Street, terminating at the Ponds Church at the corner of Long Hill Road. At the lower right is the John Post property. Note that the two large ponds shown at the bottom of the map no longer exist.

15

In 1952, Oakland celebrated its 50th anniversary as an independent community. Part of its celebration was to record its growth to 1,800 people since 1902. Notice the amount of open space existing even 50 years ago. The photograph covers an area from roughly the location of the current police department to near the Mahwah border. Route 208 would not arrive for almost another decade. Ramapo Valley Road runs diagonally from the lower left corner. and the railroad runs from left to the right in the center. Can you locate the Ponds Church, the Wigwam, the Oakland Academy, and the old railroad station?

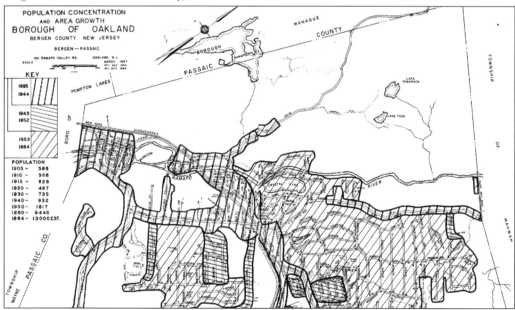

From 1695 to the 20th century, the Oakland section of Franklin Township was a tiny farming community. In 1905, the population was 586. Over the next 35 years, the population almost doubled, with 932 residents in 1940. By 1950, it had doubled again. Then, the population exploded, with a 700 percent increase between 1950 and 1964, bringing Oakland's total to 13,000 people.

16

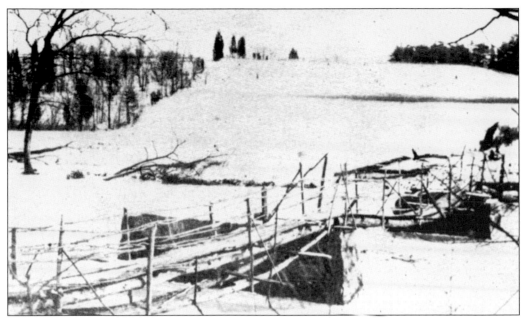

On March 3, 1903, there was a major flood that laid waste to everything along the Ramapo River. Seen here is a footbridge crudely but effectively constructed over the Ramapo River upon the remains of a former bridge. The flood also destroyed the railroad bridge, rendering Oakland the last stop on the railroad for several months. The view is from the west bank of the river, looking east up West Oakland Avenue toward the current Timbers restaurant.

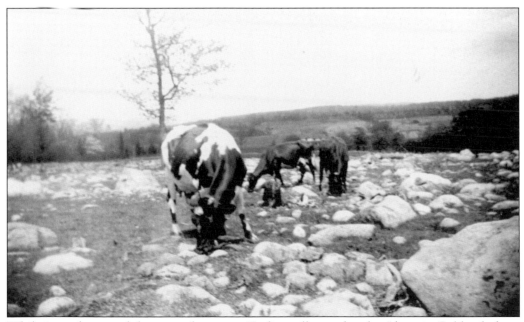

While it can be argued that once there were "Indians all over the place" here in Oakland, there may have been even more cows. This photograph shows a typical dairy farm operation in Oakland, which was somewhat common due to the mountain rocky soil limiting open farmland.

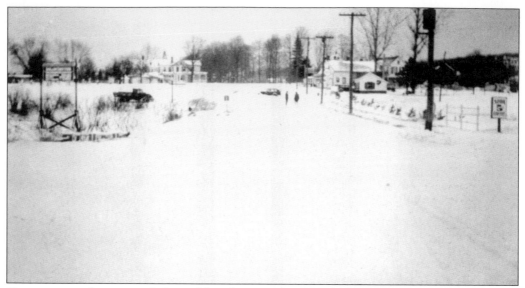

Can you guess the time and place of this photograph? Hint: the sign in the lower right promotes soda and coffee for 5¢. If you guessed that it was taken after the Blizzard of 1934 from Ahler's Corner on Route 202 looking east up Long Hill Road, you would be correct. Today, the photographer would have to be standing in a gas station parking lot.

June 15, 1938, is the date of this photograph. It is a view of the Gulf gas station, owned by Howard Johnson, along the southern portion of Ramapo Valley Road. Johnson also owned the Mandingo House adjacent to this station. As seen here, most of Oakland in the 1930s was woods and fields. The gas station, under another name and different ownership, and the Mandingo House still remain today.

This is a "lost" view of a section of Oakland, Allerman's Creek and farm, since it is quite difficult to identify the location. However, the freight train in the background provides a hint. This westerly view was taken from the hill overlooking the 84 Lumber Company toward the railroad. The creek today runs parallel to Route 287 North and is currently obscured as it passes under Ramapo Valley Road. The house in the foreground still exists on Allerman Road.

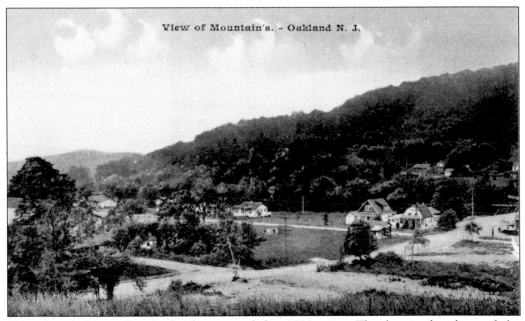

View of Mountain's. - Oakland N. J.

Two clues help to identify the location of this 1920s view. The first is the slope of the mountain, and the second is the bridge at the extreme right. The view is of West Oakland Avenue. Mostly hidden at the extreme right is Riverside Rest, a swimming and resort area then. The building is now the Timbers restaurant.

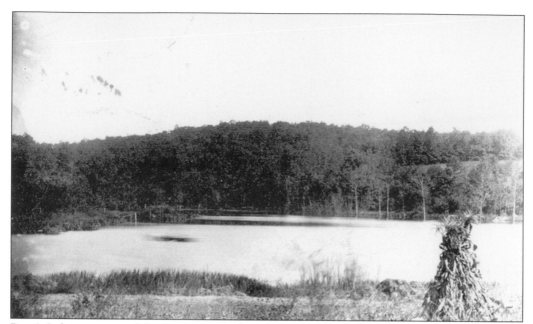

Page's Lake was part of the Page estate. This picture was taken in 1906. Located immediately adjacent to Hiawatha Boulevard and surrounded by lovely homes, it is now known as Mirror Pond.

Look closely and you will see a black cat at the feet of this trio. The identities of the young women are unknown, but the location where they are standing c. 1910 is known. They are posing on the future site of a nursing home. Directly behind them is Breakneck Road, and the field beyond, in the distance, is the future site of the McBride Industrial Park.

Two

A VALLEY OF HOMES

People have been living and working in Oakland for 300 years, since *c*. 1695. In this chapter is a glimpse of homes from a different era that add to the flavor, character, and texture of Oakland's past. These are houses once lit with candles, coal oil, and gas, where cooking was done first on an open hearth until the introduction of the wood-burning stove. While certainly most of the 18th-century homes are gone, Oakland is very fortunate to have several surviving examples from that period. Oakland is equally fortunate to have a few remaining 19th-century homes, although ironically, more remain from the 18th century than from the 19th century.

Bert McNomee's home, located in the center of town, is now the beauty salon near the rear of Oakland Drugs. The building still exists, although greatly modified by the replacement of the Victorian porch with brick-faced storefronts.

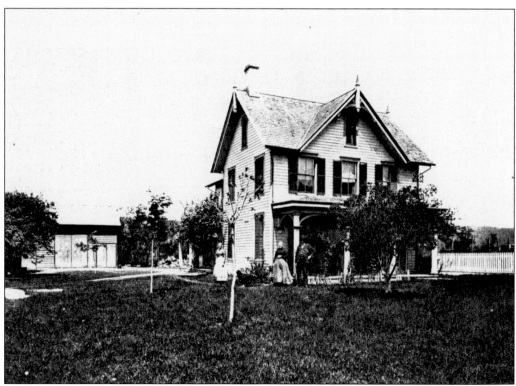

Seen here is the home of D.C. Bush and his wife, the parents of D.C. Bush Jr., the town postmaster. This house served as the railroad ticket office until the train station was erected in 1871.

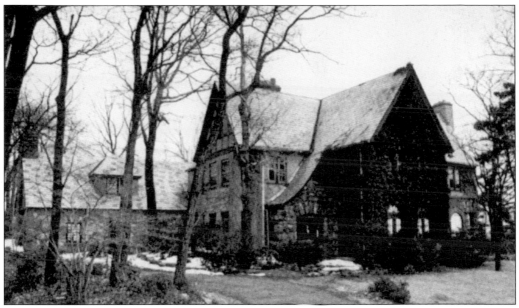

The Clifford MacEvoy house is seen in this c. 1923 photograph. Located on Skyline Drive near the Passaic County border, this house was built in the English Cottage style that was popular in the early 20th century. The builder and first owner, Clifford MacEvoy went on to become the mayor of Oakland from 1936 to 1940. From the late 1800s to the 1940s, MacEvoy's property included a private golf course, Rattan Lake, and private hunting and fishing facilities. Today, it is part of the state forest system.

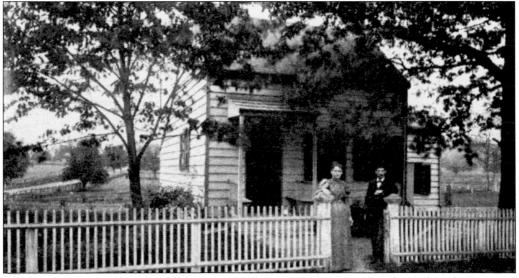

This house was owned by Thaddeus Garrison, the son of John A. and Jershua Edwards Garrison. Although Garrison was not a member of the first council, he was nominated to serve as the first borough clerk. After two years as clerk, he was elected to the borough council, where he served for 26 years. His longevity in office was exceeded only by his cousin Albert McNomee. The Garrison house was located directly across from the 1829 Ponds Church on corner of Ramapo Valley Road and Long Hill Road. The corner eventually became Ahler's Corner and ultimately the location of an Exxon gas station.

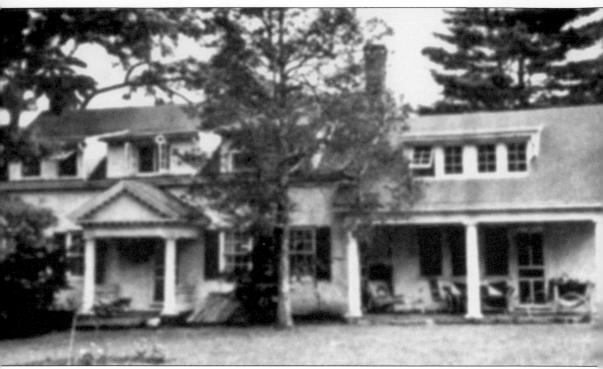

Shown is the Ackerman House, located on Ramapo Valley Road. It was built in 1747. The Ackermans were a leading family in Oakland during its Colonial days and one of the founding families of Bergen County. This house remained in the family for many generations in the 18th and 19th centuries. In the early 1900s, it was acquired by Phyllis Page, daughter of Ed Page, who owned more than two square miles of Oakland for his mansion and dairy business.

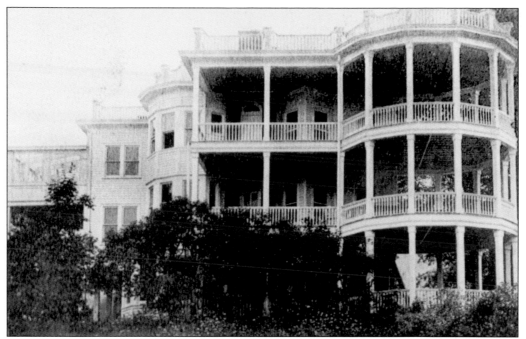

The Vernam house was the home of Mrs. Remington Vernam, of New York society fame. Also known as the Lilac Manor, it was located on the south side of Route 202 immediately south of the present Shop Rite. Previously, it was the Ramapo Sanatorium.

Built c. the 1840s, the John H. Spear house is located at 115 Long Hill Road, along one of the oldest thoroughfares in the southern section of the borough. It is in the general vicinity of the original location of the nonextant Ponds Church. John Spear was the owner of a sawmill in the current woods between Long Hill Road and Grove Street, a little farther north on Long Hill Road. Perhaps Spear's association with the sawmill industry accounts for the fine woodwork found in this house.

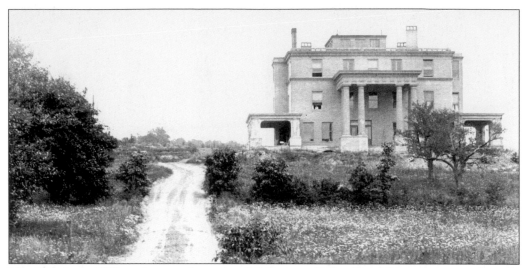

The 1909 Ludo Wilkens house is located at 222 Ramapo Valley Road. This mansion is the only structure in the borough in the Neo-Classical style. According to local lore, Ludo Wilkens chose to build his house of cinder block since he was a seven-term chief of the Oakland Fire Department and was incredibly fearful of fire. He also was the owner of the Wilkens Brothers brush factory, which employed 100 people and supplied bristles for all types of brushes to an international market. This home became a Pontifical Institute for Foreign Missions until 1995, when it was sold to a Korean Christian denomination.

The c. 1770 Jacobus Demarest house is located at 252 Ramapo Valley Road. The exterior of this house was built using broken local stone. It is included in the Thematic Nomination of the National Register of Historic Places for the early stone houses of Bergen County. It is designated with a Bergen County historical marker.

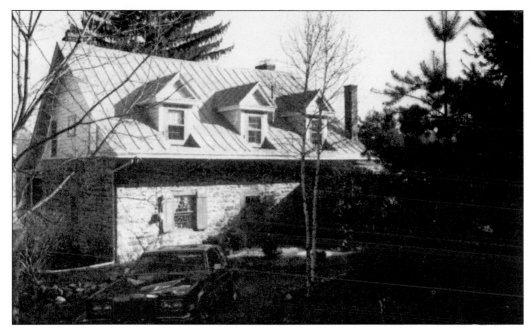

The *c.* 1799 Demarest-Hopper house, located at 21 Breakneck Road, is similar to the Ackerman house, at 1095 Franklin Lakes Road. There is one notable difference between the two houses: the Ackerman house does not have exposed interior beams.

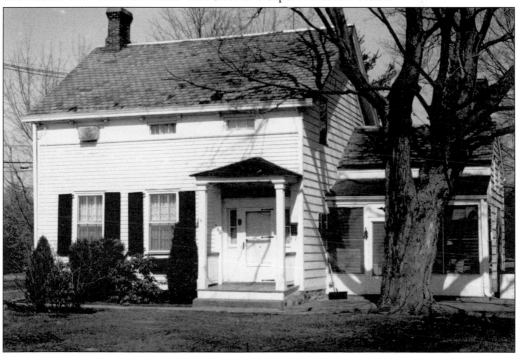

The Mandingo house, a Greek Revival–style home built *c.* the 1840s, is located at 266 Ramapo Valley Road. J. Mandingo operated a nonextant blacksmith shop on this property from the last half of the 19th century until the early 20th century. The blacksmith shop was demolished in the mid-20th century.

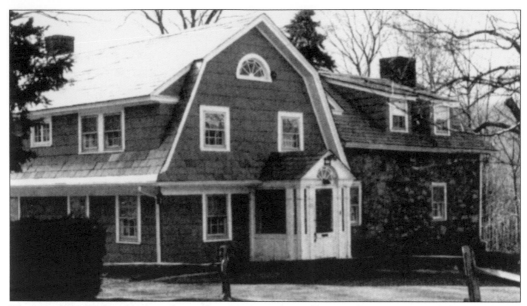

The Van Winkle Fox house is located at 669 Ramapo Valley Road. It is estimated that this home was built before the Revolutionary War. The deed has been researched to verify that Jacob Van Winkle and his wife sold this home to Jacob D. Fox in March 1828. In November 1849, it was transferred to Jacob J. and Ellen Fox. It is included in the Thematic Nomination to the National Register of Historic Places for the early stone houses of Bergen County.

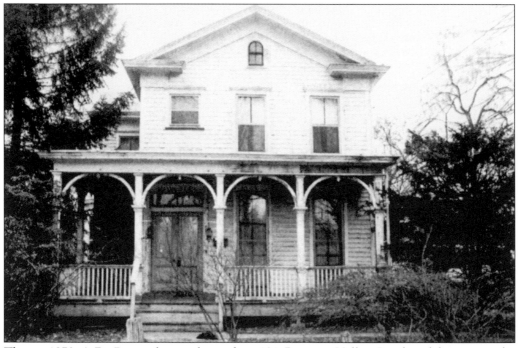

The *c.* 1870 A.D. Bogert house, located at 191 Ramapo Valley Road and known as the Aspenwood Tourist Home, is a little-altered example of vernacular Italianate architecture. By 1876, the owner, A.D. Bogert, established a wood tyne factory west of the home, near the Ramapo River. In 1894, this site became the Wilkens brush factory.

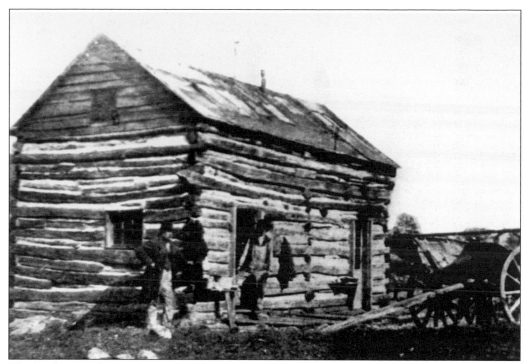

The Dickerman house, located in the Ramapo Mountains, was the home of John Dickerman and his family. In the first recorded act of arson in Oakland, this home was destroyed by fire on December 12, 1910. Fortunately, the ox and livestock were spared, as the barn did not burn down. The Dickermans subsequently moved to West Oakland Avenue, where their descendants still lived in the 1950s.

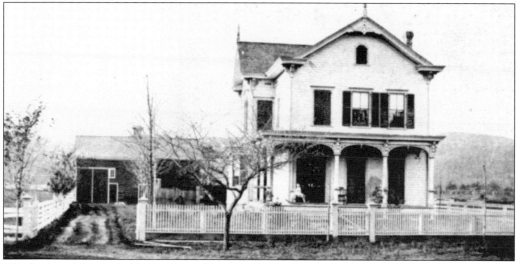

The home of Jacob A. Terhune, on Ramapo Valley Road, is pictured in the 1880s. The boy riding a hobbyhorse on the porch is Ezra M. Terhune, a longtime Oakland tax assessor and collector. Believe it or not, this house still exists, although greatly modified with the addition of brick storefronts.

This is a view of the Ramapo Valley Road and West Oakland intersection. The house in the background, currently 410 Ramapo Valley Road, was the home of Louise Sheffield, the founder of the Oakland Public Library. Prior to its purchase by the Sheffield family, it was the Van Blarcum Hotel. The building also served as the Oakland post office and Oakland's first telephone exchange.

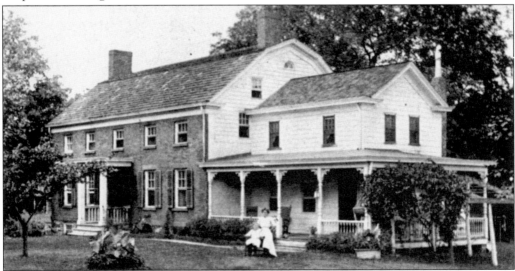

Built in 1760, the Demarest house remained the home of the Demarest family until the mid-20th century. Located on Ramapo Valley Road in the southern portion of Oakland, the Marquis de Lafayette reportedly visited here during his tour after the American Revolution. The porch wing was build immediately prior to the Civil War. Big Jim, a slave of the Demarest family, wept on the floor of the south parlor room in 1863 after hearing about the Emancipation Proclamation that was read at the 1829 Ponds Church. This house was the first in Oakland to install indoor plumbing. A small smokehouse used for curing meat is still present on the south side of the house.

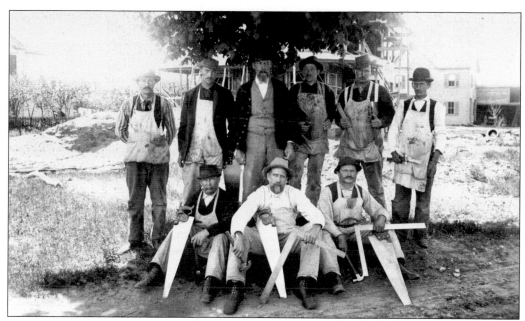

Seen here are the carpenters who built the Lloyd house, the childhood home of Doris Sanders. The house is located on the corner of Ramapo Valley Road and Spruce Street. Built in the 1880s, it is hard to image in this era of power tools that the entire house was built with a hammer, handsaw, square, and a few hand drills. It is believed that this house was built by the same Mr. Lloyd who owned the general store in Oakland. After extensive modifications to the front of the building, today it is a music store.

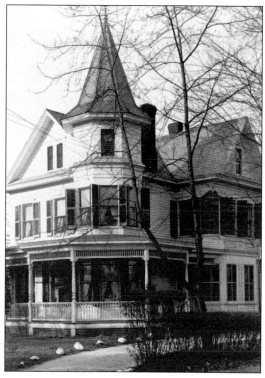

Seen here is the completed Lloyd house. A child who lived here during Prohibition recalled the noise of trucks on Spruce Street making their daily runs to pick up their cargo of bootleg liquor from an illegal still in one of the former Wilkins brush factory buildings.

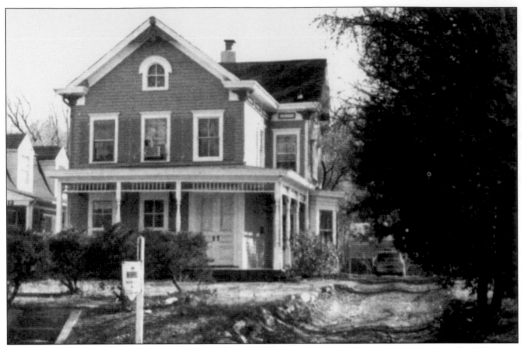

The *c.* 1850 John Winters house, located at 277 Ramapo Valley Road, remained in the Winters family from 1861 to 1913.

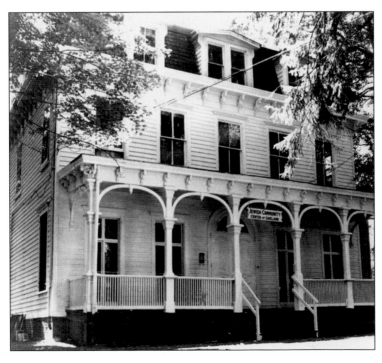

Shown is the Spear-Bush house, located on the southern section of Ramapo Valley Road immediately below Grove Street. A fine example of 19th-century architecture, it was the ancestral home of the Spear family. It is shown here in the early 1960s as the Oakland Jewish Community Center shortly before it was demolished.

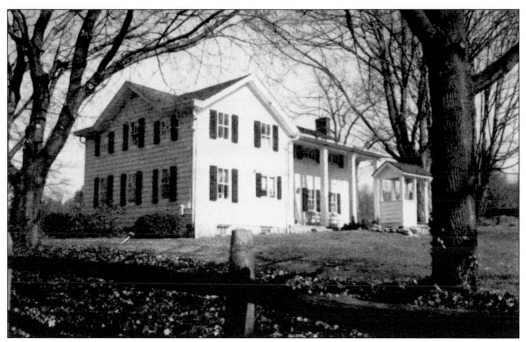

Seen here is the A.J. Hopper house.

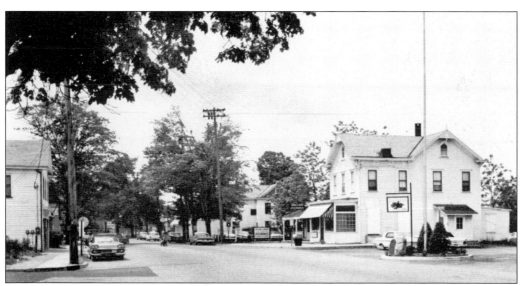

Bush Enterprises owned this building in the center of town, seen in this southerly view. Over the years, this building served the community as a real-estate and insurance office, a dry-goods store, the post office, the local telephone company office, and also the Oakland branch of the Oakland Building and Loan Association.

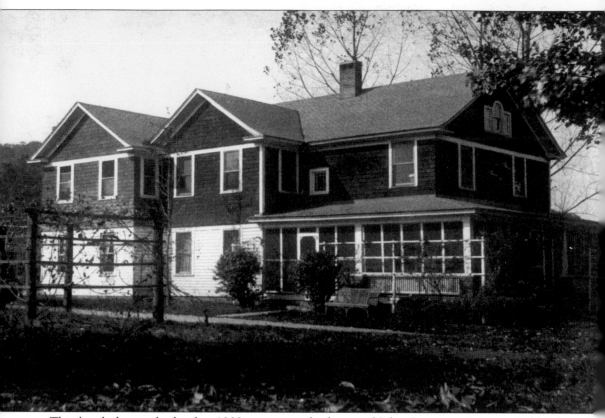

This lovely house, built after 1900, was once the home of John Post, a prominent Oakland resident for whom Post Road was named. In the 1920s, the house was purchased by the Elias Otto family. Today, it is Otto's Floral Manor, located on 16 Long Hill Road. Dr. Sam Otto, the first physician in Oakland, used the rear section as his office, and even today, his small examination rooms can still be seen. Small summer cabins were erected in the 1930s on the five-acre property to capitalize on Oakland's business as a summer resort. In the 1960s, these summer cabins were winterized by Irving Otto and are still rented throughout the year. Helen Otto, Irving's wife, manages Otto's Floral Manor business today.

Three

THE PAGE ESTATE AND THE VAN ALLEN HOUSE

During the latter part of the 19th century and into the 20th century, Oakland's farms began to experience an economic decline due in part to their relative small size. Their future was very uncertain. However, amidst this decline, a very successful businessman and gentleman farmer from New York City stepped in and bought almost a quarter of Oakland in the late 1800s. That was an area of more than two square miles of the town. His name was Edward Day Page. His farm encompassed almost the entirety of the Mountain Lakes section of Oakland. The size of this farm and estate can be partially measured, as the entirety of Hiawatha Boulevard today was his private driveway leading to his mansion. Originally dubbed the Vygeberg farm, it was a dairy farm taking advantage of the rocky soil and grazing land. Page built a family mansion, massive study, library, and barns. In some ways, it may well have been a very early example of modern agribusiness. The Van Allan House and the Stream House, as we know them today, were part of the Page farm complex.

The Van Allen House was built *c*. 1740 and is one of the oldest buildings in Oakland. It was salvaged from the wrecking ball in 1963 by the borough. Today, it is the home of the Oakland Historical Society. The main building is the original structure, and the right side addition (keeping room and kitchen) was added in the late 18th century. When this building was acquired by Page as part of Vygeberg farm, he initiated several architectural changes to it. Most obvious is the roofline, which is a late-19th century stylized version of Dutch Colonial architecture. Added, but since destroyed, were several other buildings adjacent to the Van Allen House. Only remaining today is the current farm museum, which is believed to be a rear extension of one of these buildings.

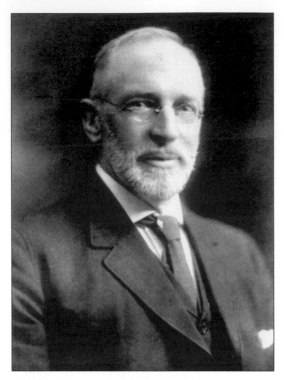

Edward Day Page, the owner of the Vygeberg farm (known as the Page farm) was a highly successful businessman from New York City whose American roots extend back to the Revolutionary War. He was a founding member of the Sons of the American Revolution, an Oakland councilman, and Oakland mayor from 1909 to 1911. He died on Christmas 1918.

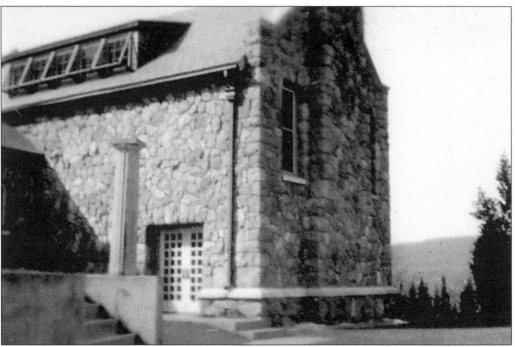

Ed Page built a massive stone addition angled to the rear of his mansion. Its use is uncertain, as some note that it was a study or library, while others insist that it was a private chapel. Although it too burned down along with the house, the stone walls were used to build a clubhouse that ultimately suffered the same fate.

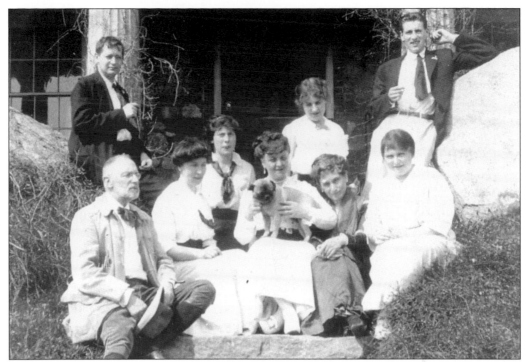

This informal portrait shows members of the Page family enjoying a sunny day in front of their mansion. Among those pictured are Ed Page (front left), his son Alan Star Page (back left), his daughter Phyllis Page (front right), and Nina Lee Page (front, second from the right). The name of the dog has been lost to history.

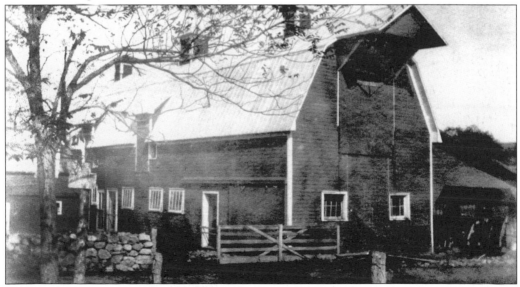

Farms and dairy cows need barns, which Edward Page did not hesitate to build on his farm. Seen here is a completed dairy barn on the Page farm. This barn today is a private residence, located on the corner of Hiawatha Boulevard and Franklin Avenue. Notice the passageway on the extreme right. It was a drive-through and part of Page's driveway. Although today it is gone, its stone support columns can still be seen.

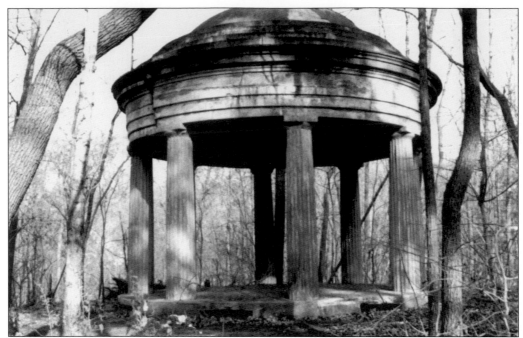

Having a mansion on top of a mountain in the late 1800s had some minor drawbacks. One is the availability of water, since a well was not feasible or economically practical. The photograph shows a cistern, a solution built by Page to gather rainwater for use in his mansion. Unfortunately, not a trace of this beautiful structure can be found today.

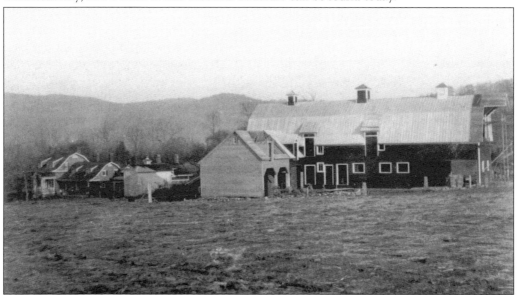

This is one of the earliest photographs of the Page farm and provides an excellent view of the continuity of the original farm buildings. It is a westerly view taken *c.* 1895 from Franklin Avenue just above Hiawatha Boulevard. In the background are the Van Allan House and its extended buildings. In the foreground is a cow barn, seemingly under construction. Page would enter his farm in front of the Van Allan House, proceed past the extended buildings, and continue on the opposite side of the barn to his mansion on top of today's Hiawatha Boulevard.

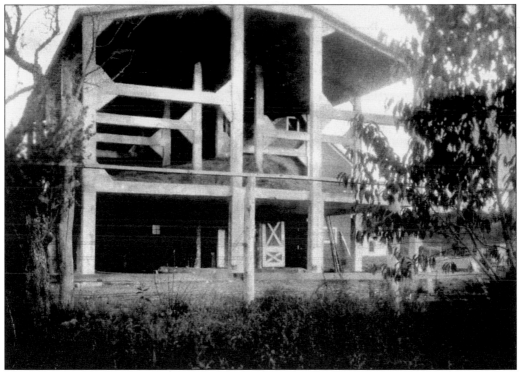

This is the second cow barn built by Ed Page for his expanding dairy herd. The barn, although in a state of partial collapse today, can still be seen behind the residence of the late Frank Scardo, on Franklin Avenue.

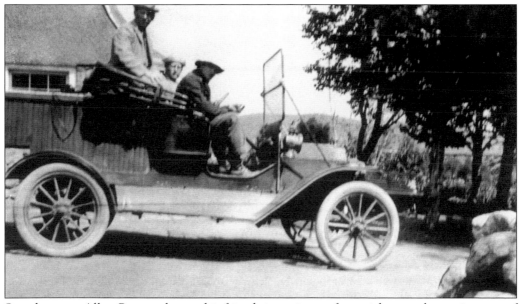

Seen here are Allan Page and some his friends in a vintage farm pickup truck, passing one of the Page farm stables where Star, a favorite horse of Phyllis Page, was kept.

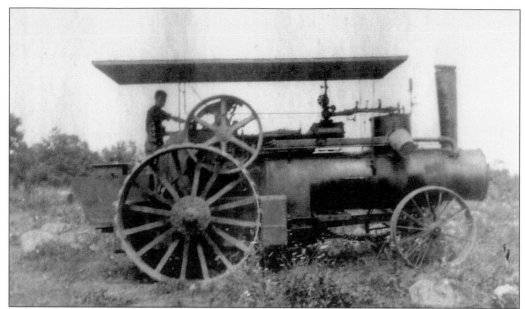

Farm equipment has come a long way, as illustrated by this photograph. Here is Alex Page, son of the Page farm manager, working with a newfangled steam-powered farm traction engine.

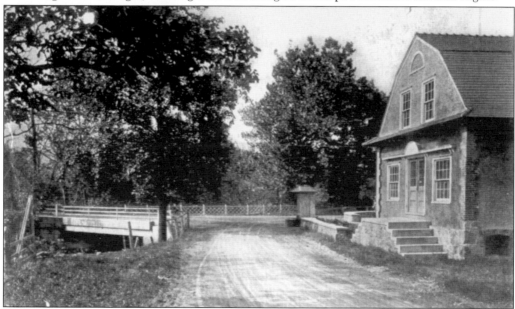

This building, known as the Stream House, was built by Ed Page as the business office of the Vygeberg farm in 1902, a full 14 years before electricity came to Oakland. The building is unique in two ways. First, it is built over a stream so that the water can cool the foundation and basement, where the dairy products were stored. Second, while looking rectangular, it is in fact constructed on an angle thereby presenting interesting carpentry challenges in its construction. It had been virtually abandoned by the borough since its acquisition in the early 1960s, although attempts are being made to restore it by volunteers. It is seen c. 1910, during its better days. Notice the full height of the stairs and street walls. Franklin Avenue was widened and regraded in the late 1920s by Bergen County, which caused the partial burial of the walls and stairs.

[Handwritten letter by George Washington, dated July 14, 1777, written "8 miles from Pompton Plains." The body is in cursive and largely illegible.]

420

Van Allen, 8 Miles from Pompton Plains
July 14: 1777.

Ranking highest among the many claims to fame of the Van Allen House is the fact that George Washington actually did sleep here on July 14, 1777. This is authenticated by a letter (above) written by him when he was "8 miles from Pompton Plains." The original letter is preserved in the archives of the Library of Congress, in Washington, D.C.

41

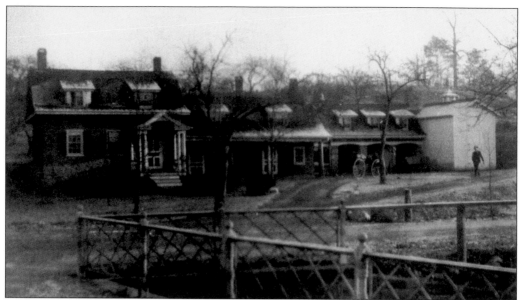

This is one of the earliest known photographs of the Van Allen House. It was taken prior to 1902 and after Ed Page made extensive modifications. Notice the horse and buggy. This picture shows four seemingly attached buildings. However, the original section, on the extreme left, dates to *c*. 1740. The next section was added to it later. The third section is actually detached. The large white building is estimated to be an icehouse for the dairy farm due to its design. Only the Van Allen House and its original addition remain today. There is no information as to when the third and fourth buildings were destroyed. The Van Allen House and the Stream House, the sole remaining buildings, are owned by the borough and are two of the cultural anchors of Oakland.

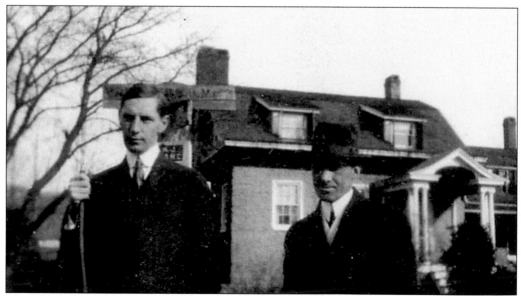

The Green brothers, Ray and Bernard, stand in front of the Van Allen House on Ramapo Valley Road *c*. 1910. Unfortunately, their association with the Page estate or the Van Allen House is not known.

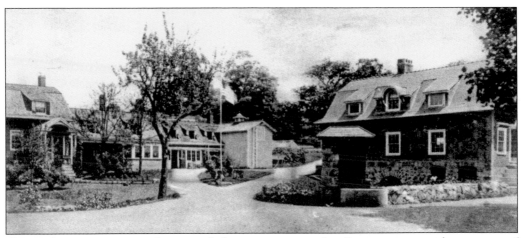

Shown here is a postcard view of the entrance to the Page estate, at the corner of Franklin Avenue and Ramapo Valley Road. The photograph was taken between 1902 and 1911. It was initially known as the Vygeberg farm and later was simply called Page's Corner. A horse-watering station is in the foreground.

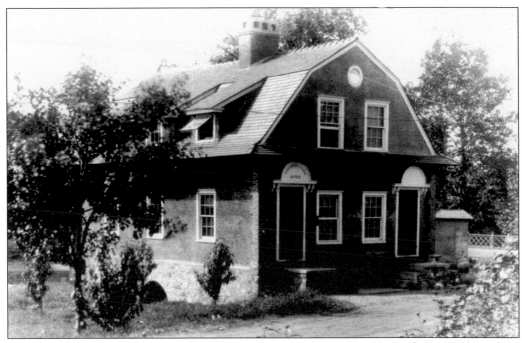

Seen in this very early photograph is the rear view of the Stream House during its best days. The main floor was the business office, with a large open space and a smaller private office complete with a fireplace. The upstairs, originally thought to be a storage area due to the presence of trap door, became private living quarters with a separate entrance (right) and was occupied through the 1950s.

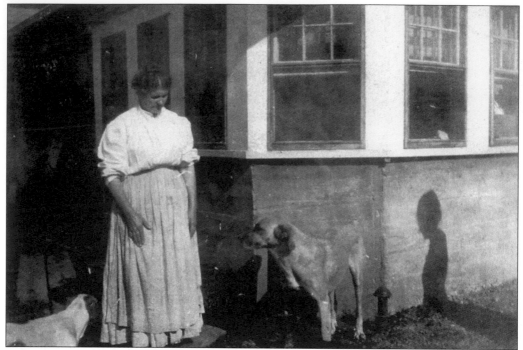

When the Van Allen House was part of the Vygeberg Farm, the house served as the residence of the farm manager, Mr. Ross. Here we see Ross's wife at the far corner of the Van Allen House with her dogs. Because of its concrete construction, that portion of the Van Allen House has been variously described as a farm washroom and as the dining room for the farm laborers. It may have been both—we may never really know.

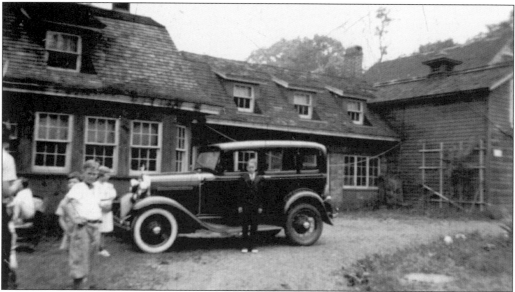

Taken c. 1935, this photograph shows that the Van Allen House had fallen upon hard times. The Page farm had been sold to a Catholic seminary, and the Van Allen House itself had become a rental unit, losing much of its luster. Unfortunately, neither the occasion of the photograph nor the names of the children are known.

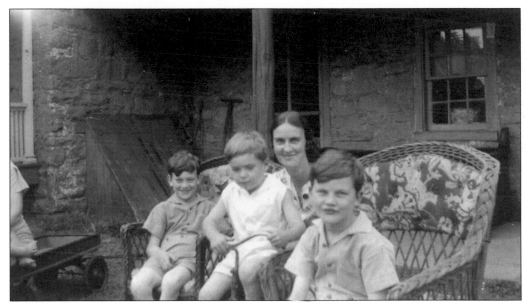

Sometimes life goes in full circles. Here we see Dorothy Van Allen with her children in 1936 sitting in front of the Van Allen House, where she lived from 1936 to 1937 for $25 per month in rent. She was related to the original Van Allen family who built the house nearly 200 years earlier. Her brother was Howard Johnson, a relative of the Mandingos, another very early Oakland family.

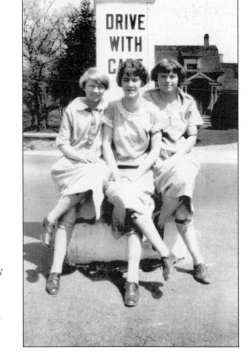

Seen here on April 27, 1925, are the Van Allen girls, from left to right, Dot, Alice, and Elise. They do not appear too worried about traffic while seated comfortably upon a traffic marker in the middle of the intersection of Ramapo Valley Road and Franklin Avenue. Posing there today is definitely not recommended.

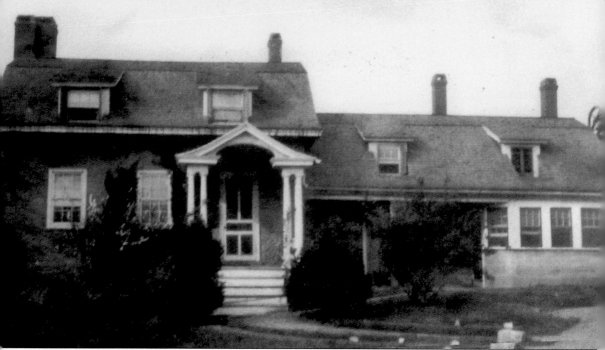

This is the Van Allen House in the 1920s, reflecting the modifications to the roof and the addition of the entrance portico made by Ed Page. Notice the double chimney on the left, which was probably added to accommodate a modern heating system. Also notice on the extreme right of the roof a bell, ostensibly used to summon the farm workers. The building and bell are both gone.

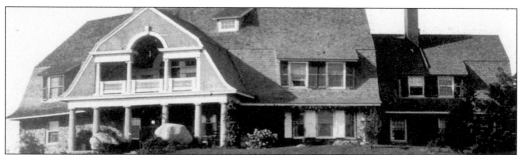

The Page mansion was built in the late 1800s by Ed Page to serve as the family summer residence away from New York City. Eventually, Page added a massive stone library and study to the rear of his mansion. After he died, the mansion was sold to a Catholic order as a seminary. Unfortunately, it was completely lost to fire.

Four
BUSINESS AND INDUSTRY

Because of the Ramapo River and Oakland's many springs and streams, waterpower was extensively used to power industry and many grist and spinning mills. Among the many industries and mills were the Wilkins brush factory, the gunpowder factory, and the Spear sawmill. In fact, the outlines of many of the millponds that powered lumber and gristmills can found even today in the remaining undeveloped woods of Oakland. However, the arrival of electricity to Oakland on August 1, 1916, foreshadowed the demise of water-powered industries and mills soon thereafter.

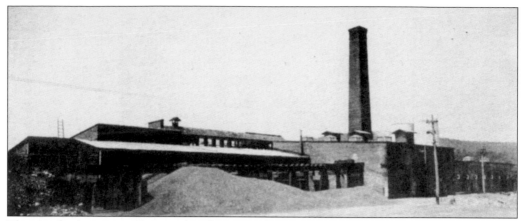

The Anglo-American Gunpowder Company factory, established in Oakland in 1890, was located at the end of Powder Mill Lane in the area that is now Lake Shore Drive. This water-powered facility suffered explosions involving fatalities. It was acquired in 1903 by DuPont. However, it was shut down in 1919 and dismantled in 1920, four years after the advent of electricity in Oakland.

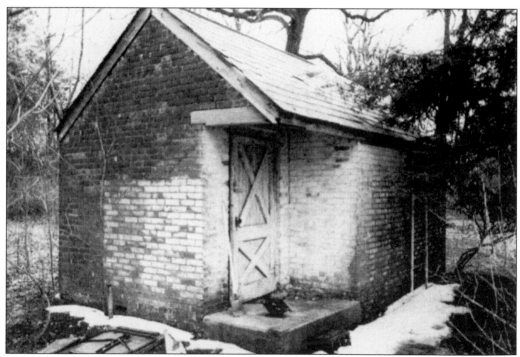

This small storage shed is all that remains today of the once mighty Anglo-American Gunpowder Company.

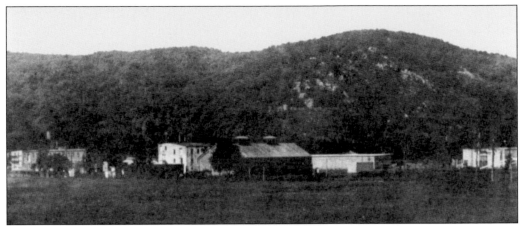

In 1894, the Wilkens brush factory began producing bristles for many different types of brushes that were sold all over the world. The brush manufacturing operation, located at the base of Spruce Street, encompassed several large buildings, of which only one remains today. Manufacturing operations were discontinued in 1928.

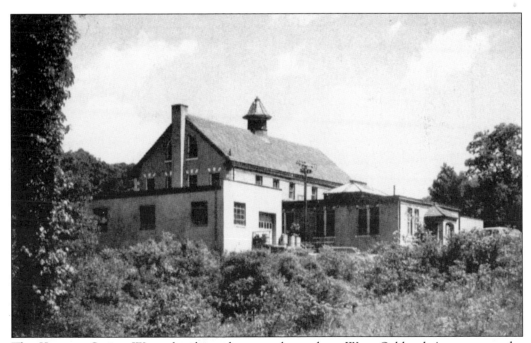

The Kanouse Spring Water bottling plant was located on West Oakland Avenue, on the western side of town. The water was piped from the Vernam Spring, near Long Hill Road close to the original site of the Ponds Church.

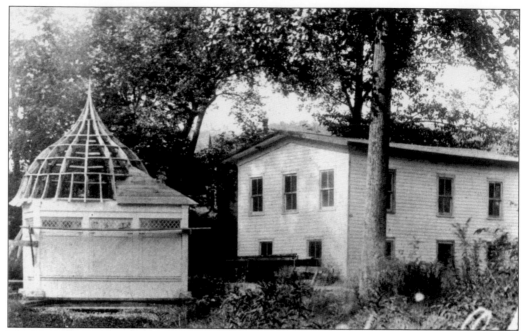

The Vernam Spring was developed in 1904 as a small commercial enterprise by Mrs. Vernam of Lilac Manor fame. She ran it until 1906 and ultimately sold it to the Kanouse Water Company, which bottled and sold the spring water throughout the area as a health tonic. The Vernam Spring augmented Oakland's public water supply during the 1930s.

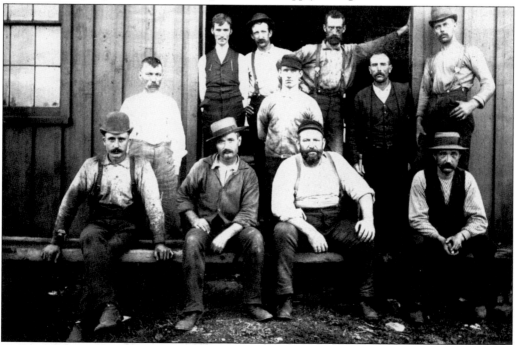

Shown are 11 workers in a local blacksmith shop before the start of the 20th century. At one time Oakland had at least two blacksmith shops for its small population, making and repairing everything from household utensils, iron gates, hinges and, yes, horseshoes and mule shoes.

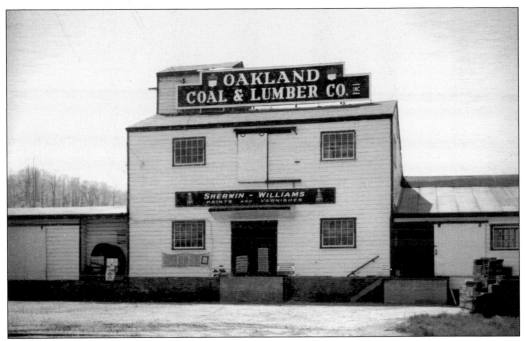

The Oakland Coal and Lumber Company was owned by Paul Schorr and his son, Harold. Begun in 1923, the business was located adjacent to the railroad line. Today, the 84 Lumber Company occupies the site, continuing the thrust of the business.

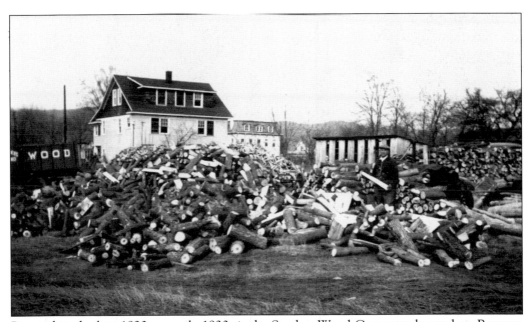

Pictured in the late 1920s or early 1930s is the Sanders Wood Company, located on Ramapo Valley Road. Today, a photographer shooting this view would have to stand in the parking lot on the north corner of Yawpo Avenue and Ramapo Valley Road.

This is a wonderful picture of Oakland's horse-and-buggy days gone by. This blacksmith shop was located on Maple Avenue directly behind the chiropractor's office. The two boys are Harry

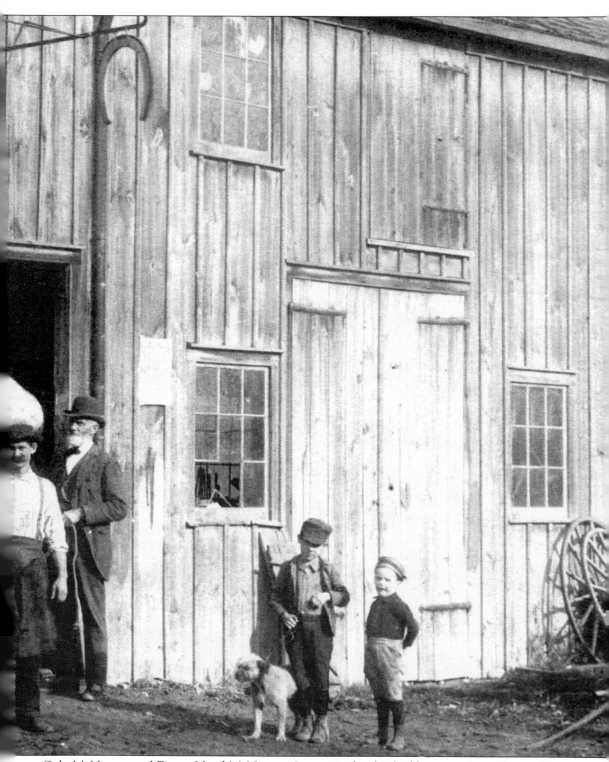

Gale McNomee and Ernest Lloyd McNomee. Interestingly, this building remains today and is used as a garage.

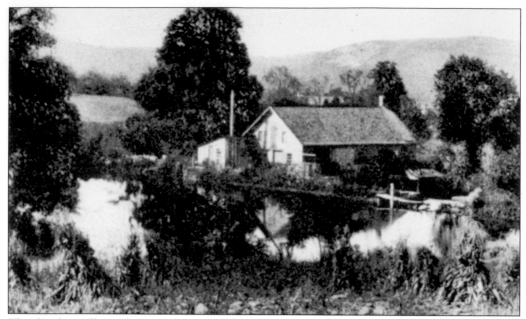

This lumbermill was built on Long Hill Road by Hank Spear during the Civil War. In later times, it was converted too a private residence by Andrew Spear, a descendant. The millponds feeding this sawmill are still in evidence in the woods along the north side of Long Hill Road.

The corner of Ramapo Valley Road and Franklin Avenue is the site of the oldest continuing industry in Oakland's history: the Vervaet Label Company, founded c. 1890. This building was originally a sawmill before it was purchased from Ed Page by Arthur Vervaet in 1921. Today, it retains a thread to its original development by being a carpet outlet store.

Five

A STROLL DOWN
MAIN STREET

If you were one of Oakland's nine or ten primary landowners in the late 1800s, Main Street was *the* place to live: to see and be seen and to watch the world go by in horse-drawn buggies from your porch. Walk down Main Street in Oakland Station, as Ramapo Valley Road and the town were then known, and visit the sights and scenes from over 100 years ago as Oakland's founders saw and lived them. Your clothes would have the dust from the dirt road that would not be paved for another 25 years. Your way at night would be lit by coal oil lamps, since electricity would not come to Oakland until 1916. Riding in your buggy from the railroad station to the 1829 Ponds Church, you would pass farms and gristmills on both sides of the road, observing that the local population increased fivefold during the summer months due to the influx of tourists. You would pass Ivy Hall, built by the Ponds Church, and perhaps attend a lecture sponsored by the Christian Endeavor Society on the evils of alcohol. During this journey, you would see the change that 100 years have brought up through the 1960s, noting them by their absence: the Calderwood Hotel, the old train station, the Bush general store, the Spear homestead, Ivy Hall, Seel's, the Wigwam, and the Nielsen house, to name a few.

This was one of two buildings owned by the Sanders family, in addition to their own house on the same property. Al Potash lived here when he first came to Oakland in the 1920s. The buildings were located on a property that paralleled the railroad tracks just off the east side of Ramapo Valley Road near the corner of Yawpo Avenue.

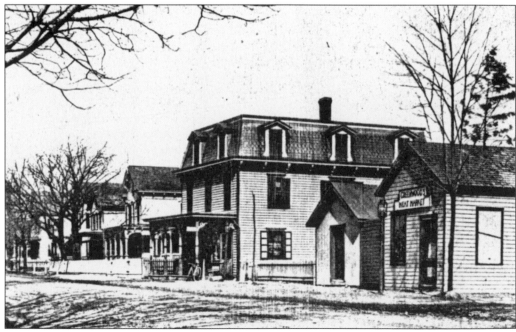

This *c.* 1885 photograph is a wonderful alternative view of the Lloyd McNomee store and adjacent houses on Ramapo Valley Road. In the foreground is Greenwoods Meat Market.

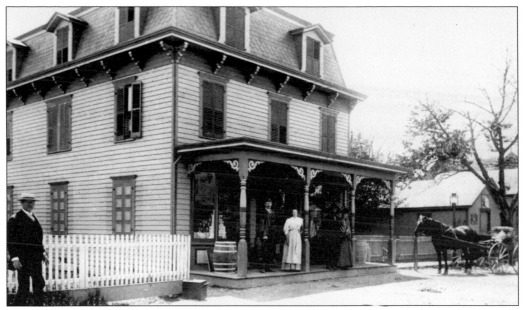

Pictured above is the Lloyd McNomee general store as it looked in the 1890s. Lloyd McNomee was a leading citizen and founding father of the borough of Oakland. Although greatly modified, this building still exists. Look for the roofline on Ramapo Valley Road just south of Yawpo Avenue and you will find it. The buildings to the right are a feed store and a butcher shop. Notice the kerosene lantern, one of many streetlights in Oakland prior to the advent of electricity here on August 1, 1916. Standing on the porch at the right are John S. Sanders and Lavina Yelley Sanders.

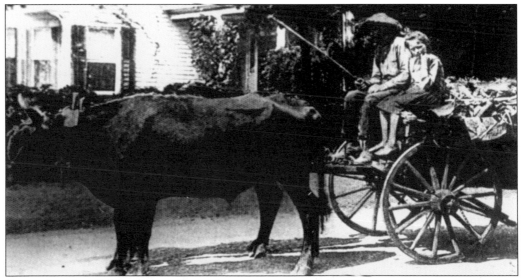

Few realize that Oakland was a sleepy farming community for 200 years prior to incorporation in 1902. John Dickerman and his daughter pass the Mandingo house, on Ramapo Valley Road, in an oxcart, while bringing farm produce to town. Note that the little girl has no shoes or socks. Dickerman's house, a log cabin in the mountains, was burned to the ground by vandals in 1912. Although oxcart traffic may be gone, the Mandingo house remains to this day as a rental house.

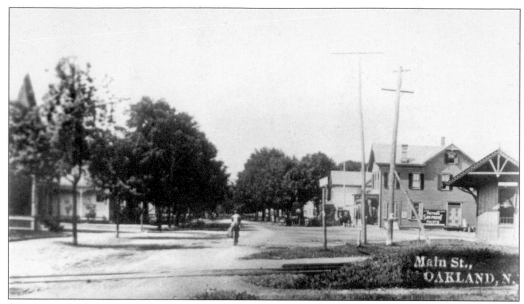

This view, looking south from the railroad tracks, shows a man on a horse on Main Street (now Ramapo Valley Road) *c.* 1900. Notice the corner of the old railroad station on the right and the side view of the Bush general store, which remains, albeit greatly modified, as McNally Engineering and the office of Dr. Kook, D.D.S.

Oakland has historically been a Republican community and showed it with this Goldwater float during Oakland's parade on July 18, 1964, celebrating the New Jersey tercentennial anniversary. John Little, the retired principal of the Lincoln School, in Ridgefield Park, was the Oakland tercentenary chairman and was named Citizen of the Year by the American Legion Post 369 in Oakland for his contributions to the success of the parade.

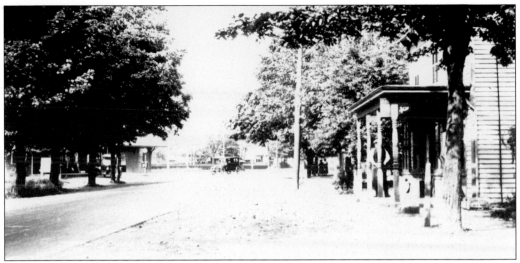

Looking north from the Lloyd McNomee store on Main Street *c.* 1915, an unidentified man stares at that new contraption, the automobile, in a community that still depended upon horse and wagon for transportation. To the extreme left is the old railroad station, and in the distance is the residence of D.C. Bush, Oakland's first stationmaster.

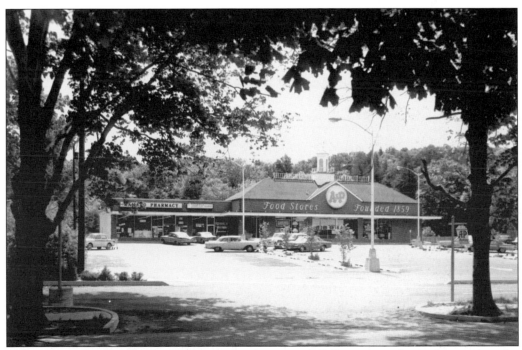

Not to be outdone by the Grand Union, the then new A & P store was the anchor in this, the third shopping mall in Oakland. That A & P is now the home of the Oakland post office. This mall was subsequently expanded to the left, adding the current Drug Fair store that replaced the former Foodtown, which opened after the A & P departed. The expansion of retail space necessitated the destruction of the Nielsen house.

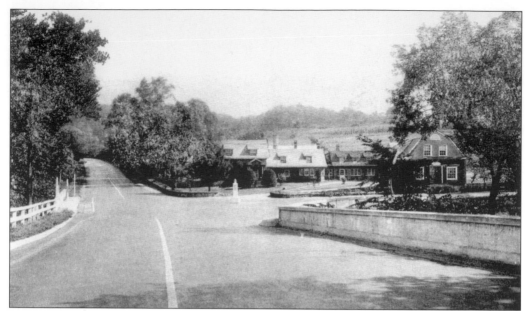

This is a view of Pages Corner, as it was known in the 1930s. The building on the right is the business office of the Page farm, and the one on the left is the home of Mr. Ross, the Page farm manager. This intersection is the site of Oakland's first recorded automobile accident, which took place on June 10, 1910, when a chauffeured car carrying Mrs. Lincrum and her two daughters, who were traveling from Hackensack to Newfoundland, failed to negotiate the turn. Fortunately, no one was seriously injured. The family was treated by Dr. Hamilton at the C.C. Jones home prior to returning to Hackensack with a few bruises and unpleasant memories of Oakland.

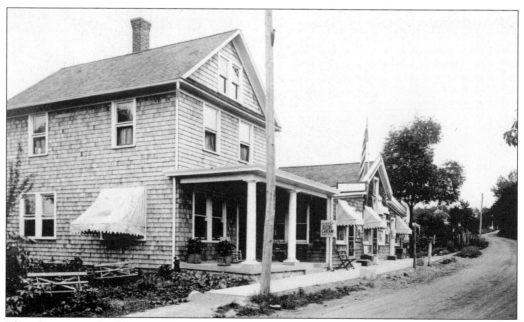

This distinctive building is that of the Van Orden store, located on Franklin Avenue. The building still exists and is currently a private residence.

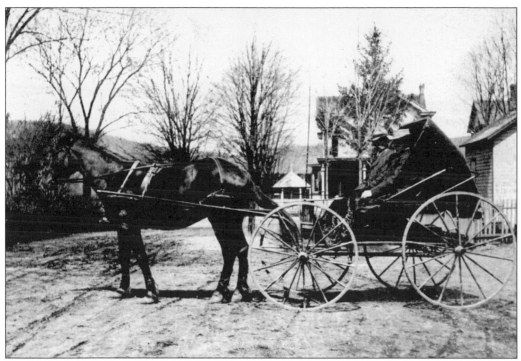

In the horse and buggy is Albert McNomee, ready to fight traffic while going to an appointment *c.* 1890.

Automobile traffic jams came slowly to Oakland. Here, an unknown resident makes a delivery from a horse and wagon *c.* 1910.

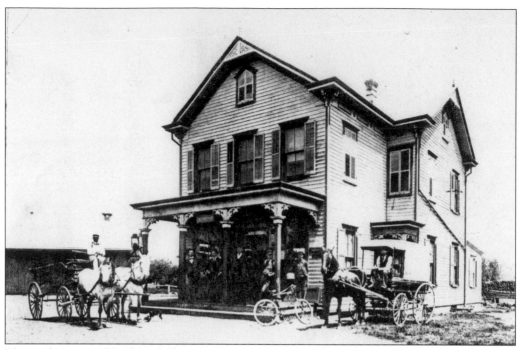

This is the original Bush and Shuart store, on Ramapo Valley Road, in 1888.

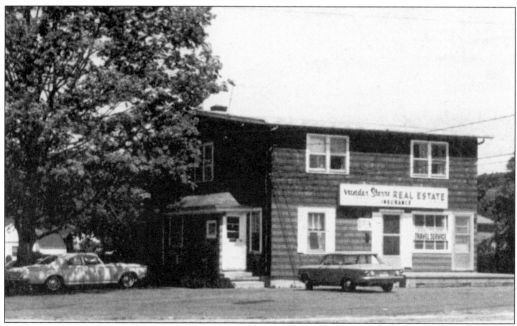

This is considered Oakland's first professional building. Located on Ramapo Valley Road, it was once owned by Lillian Cummings, Oakland's telephone operator. Subsequently, it was purchased and moved to its final location by John Merrey for his law practice, a dental office, and an optometrist office. Sterre Brothers real-estate offices joined the complex. The building no longer exists, as it was destroyed to accommodate the entrance ramp onto Route 287 South from Ramapo Valley Road.

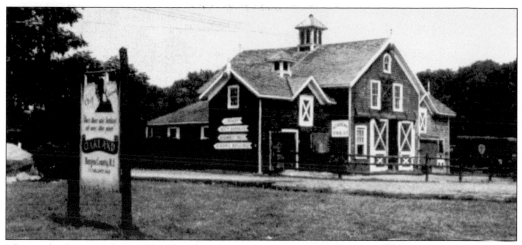

This is the barn of the Oakland Military Academy, located on Ramapo Valley Road. The signs on the side of the barn give directions to the library, north barracks, assembly hall, and academic buildings. The sign at the left shows a picture of Chief Laopooh and politely informs the casual passersby that "Once there was Indians all over this place."

As a clear sign of Oakland's growth, Mayor Al Potash (center) helps dig the first spade of soil for the new Grand Union supermarket in 1957. It was located on the west side of Ramapo Valley Road, roughly behind the current Ponds Church. This was the second shopping mall in Oakland. The original Grand Union supermarket, after moving across the street to the Copper Tree Mall, ultimately became a Sears outlet store and then Oakland Hardware, as it is today.

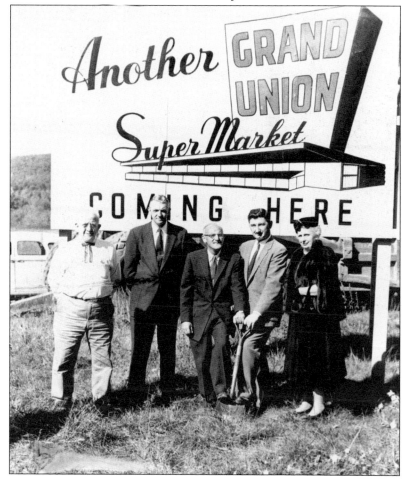

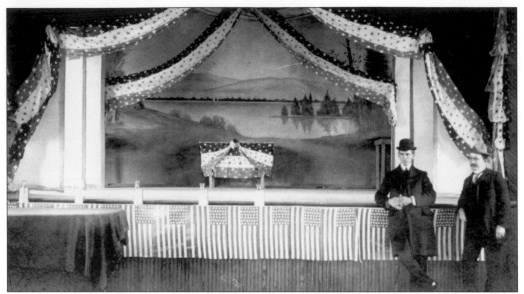

Two men stand in front of the stage on the first floor of Ivy Hall prior to 1900. If you look closely, you will notice that there are 36 stars on the flags in front of the stage.

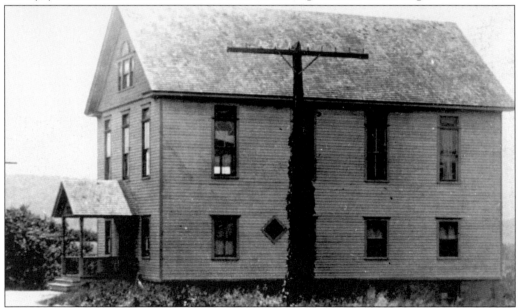

Ivy Hall was built in 1880 by the Ivy Society of the Ponds Dutch Reformed Church as a social and meeting hall for the congregation. It was located on Ramapo Valley Road between Oakland School No. 1 (the board of education building) and the current police station. It was also the home of the Christian Endeavor Society, which, on November 11, 1903, sponsored a particularly ineffective lecture entitled "How We Abolish the Saloon." Nonetheless, it contained a large dance hall, dining rooms, and council quarters. Shortly after Oakland became incorporated as a borough in 1902, the hall was purchased by Oakland and was used as the town hall until 1922, when it burned down. The fire was discovered by patrolman Charles Meridith at 2:30 a.m. Fortunately for posterity, the foundations of its two outhouses and the main building can still be seen.

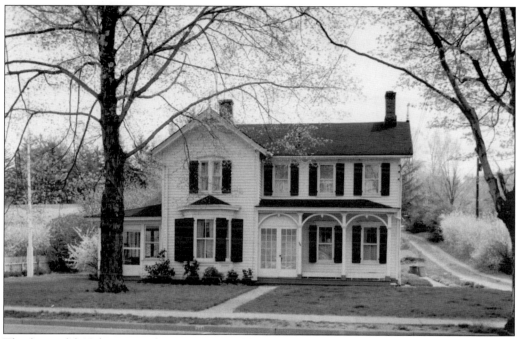

This beautiful 19th-century house was owned by Miss Nielsen. It was located on Ramapo Valley Road south of and immediately adjacent to the Copper Tree Mall. It was destroyed to expand the strip mall and make room for a parking lot.

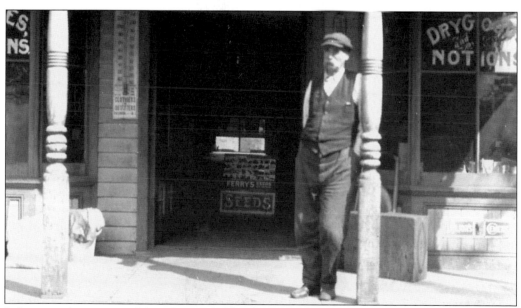

Life in simpler times on Main Street, Oakland, is so well expressed here in this scene of Albert McNomee in front of his store. Not much seems to be going on in this town of 548 people in the very early 1900s. Notice the window sign Dry Goods and Notions. What is a notion?

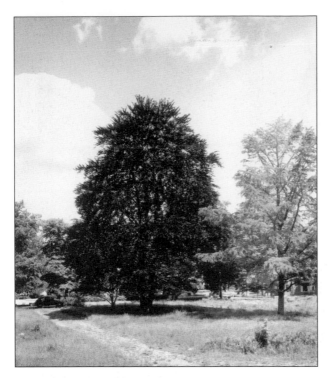

If you look closely at the perimeter of the Copper Tree Mall facing Ramapo Valley Road, you will see this tree protruding in its own space into the parking lot. Although one might think it odd to include it in a book on Oakland, the tree has a history all its own. Likely the oldest tree in Oakland, it was standing when Washington passed by in 1776. Furthermore, it is virtually the sole remaining element of the Calderwood Hotel and Oakland Military Academy. Finally, when the mall was being built and this tree was threatened to be taken down, a local woman chained herself to it and successfully preserved it.

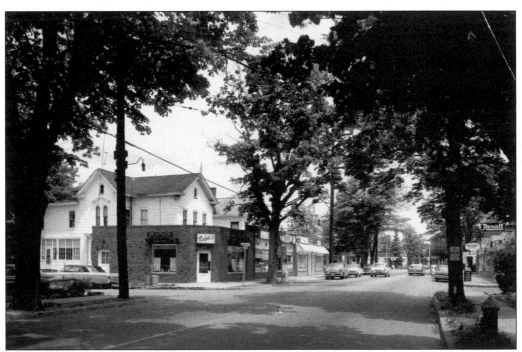

"Sleepytown, USA" might well describe this view of Oakland's business district. Taken in the early 1960s, this photograph looks north from the empty lot that was the Oakland Military Academy. Ralph's Pizza is now a bank. Notice the Victorian homes whose fronts have been extended to create stores. Also notice the tree-lined street.

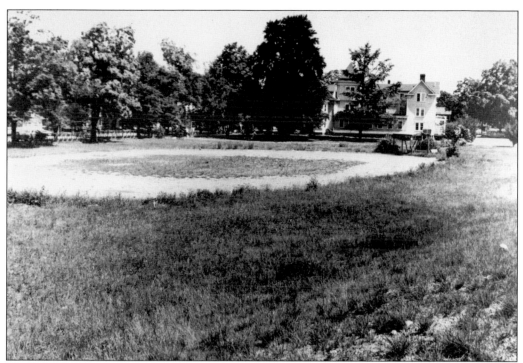

After the destruction of the Oakland Military Academy, formerly the Calderwood Hotel, on August 21, 1962, this site remained fallow, waiting to become mostly a parking lot.

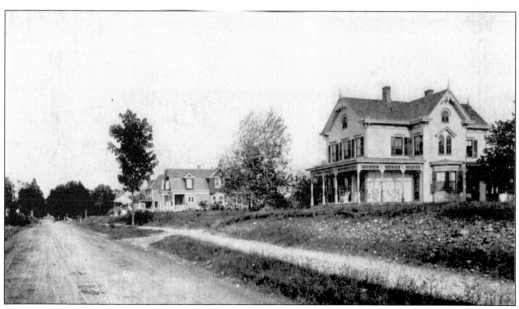

This view, looking north from near the site of the current police station, shows Oakland Avenue, as Ramapo Valley Road was then known, in the 1920s. Note that the road is not yet paved and sidewalks are not yet installed.

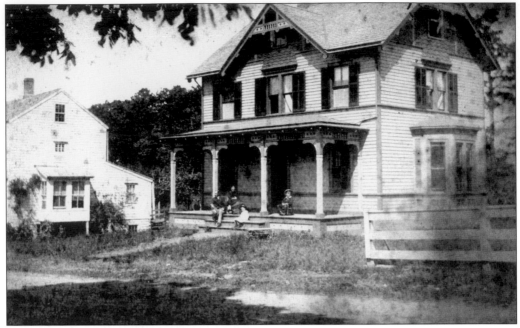

This is another view along Ramapo Valley Road c. 1900. The building is believed to be the Butchers Hotel, which is long since gone. Unfortunately, the names of the individuals in the photograph are unknown.

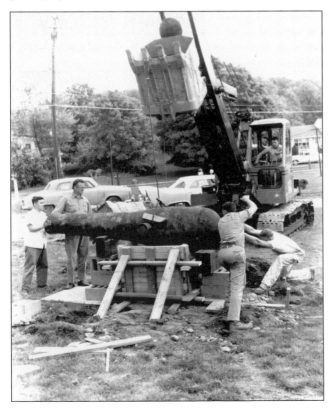

In the 1960s, Veterans Park, located on Ramapo Valley Road, was greatly enhanced by Mayor Al Potash. Here, on the Oak Street side of the park, one of two 1850 Dahlgren cannons is installed. These cannons were the primary naval cannons of the U.S. fleet through the Civil War. These 9-inch, 9,000-pound cannons, capable of shooting a 150-pound projectile, were donated by resident Jack Dawson.

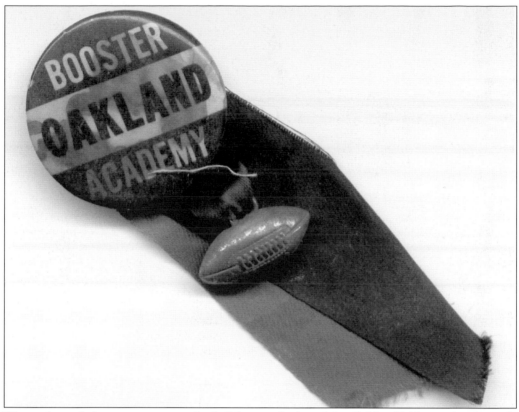

This is the only known remaining football booster badge of the Oakland Military Academy. It is in the possession of the Oakland Historical Society.

Shown is a simpler time, not really that long ago. This view, looking south from the railroad tracks *c.* 1956, shows Ramapo Valley Road The original Oakland railroad station is still standing and the Bush general store (background) has become the Wigwam, a local newspaper and confection store. Notice the old large trees that virtually formed a canopy over the street.

This aerial view, taken *c.* 1963, depicts the original Grand Union shopping center, now the Oakland Hardware store.

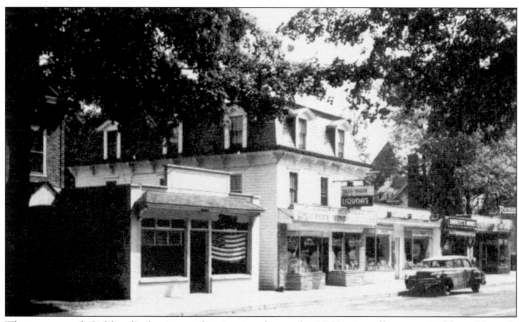

This scene of Oakland's business district in the early 1950s is still recognizable, although the store names are different now. Note that the liquor store was the original Lloyd McNomee dry goods store and that the building in the foreground, with the flag in the window, is believed to be an early Oakland post office prior to its move to the new brick building on the site of the original Oakland train station. Also note the presence of shade trees in Oakland's business district.

Seen is an idyllic, lazy day along Ramapo Valley Road at the Glen Gray turnoff at the northern part of Oakland, near the Mahwah border.

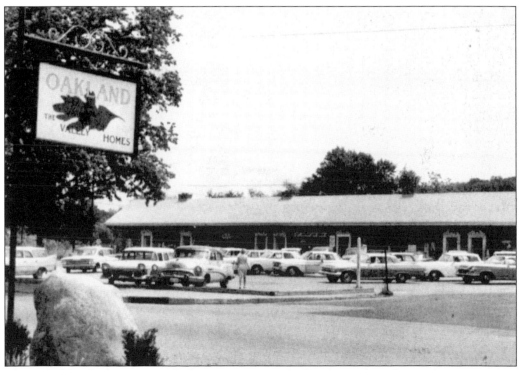

This is Oakland's first strip mall shopping center, which is located on the northeast corner of Ramapo Valley Road and Yawpo Avenue. It was originally built behind Seel's, which was located on the corner where the old Buick is shown in the photograph.

Do you recognize this intersection? Taken in the 1930s, the picture shows the corner of Franklin Avenue and Ramapo Valley Road. The seemingly continuous building on the right is the Van Allen House and the other one on the right is the Stream House. At this time, a Catholic order purchased the Page property for a monastery. The buildings directly behind the Stream House are a mystery and have disappeared without a trace.

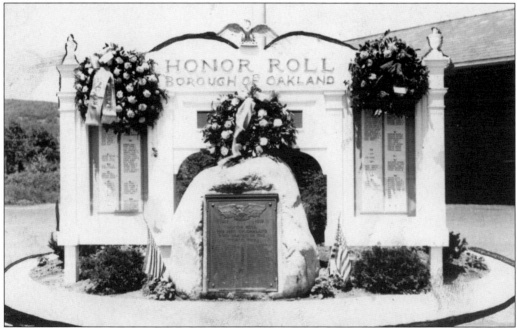

Oakland is, has always been, and will always be extremely proud of its sons and daughters who served their country. This photograph is of the original honor roll memorial dedicated to Oakland's heroes who served. It was the centerpiece of the old Oakland railroad station plaza. When the Oakland railroad station was destroyed, this honor roll, expanded to include recent wars, was moved, and it is now the pride and focal point of Veterans Park.

72

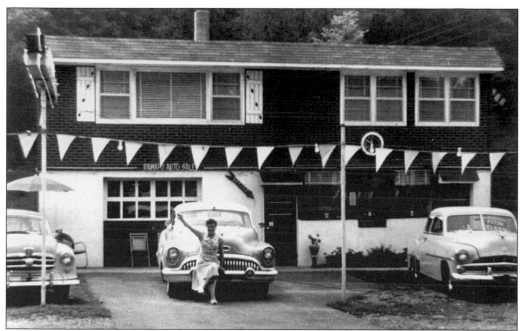

To quickly identify this building, you must have a good eye and an even better memory. Believe it or not, it is the home of the Oakland Animal Hospital, owned by the nationally renowned Dr. Robert Gordon, D.V.M., who greatly enhanced it. It is located across from the Doty Bridge on Ramapo Valley Road, immediately south the current Shop Rite. As the photograph indicates, this building in a previous life was a used car lot that was subsequently purchased by Dr. Peinecke, D.V.M., to initiate his veterinary practice. The identity of the young woman waving from the front bumper of the 1949 Buick is not known. (Courtesy of Dr. Robert Gordon, D.V.M.)

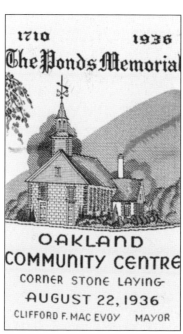

This silk badge simultaneously stitches together several pieces of Oakland history. First, it was issued in celebration of the dedication of the Ponds Memorial Building, originally serving as the Oakland municipal building and now the home of the Oakland Public Library. Second, it recognizes the importance of the Ponds Church within the community. Third, it was manufactured in Oakland at the Vervaet Label Company, whose factory building stands at the corner of Ramapo Valley Road and Franklin Avenue.

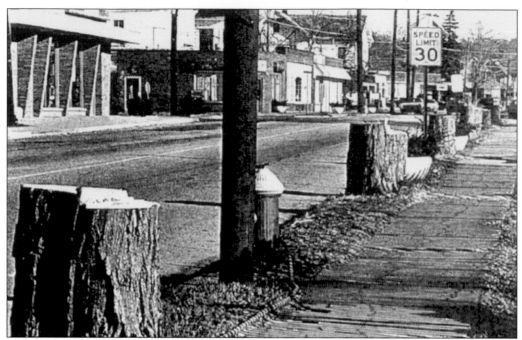

One of the charming subtleties of the photographs of Main Street in old Oakland was the presence of shade trees on both sides of the street. Shade trees were removed for the modernization of the business district c. 1961. It is reported that they were taken down during the dark of the night, ostensibly for safety reasons, and that the Oakland public was not pleased with either the trees' removal or the seemingly secretive manner in which they were removed.

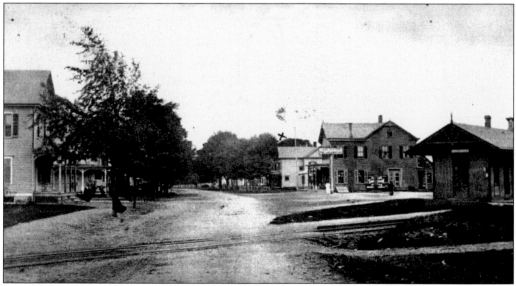

It is almost a surreal thought that one could look south on Ramapo Valley Road and view this scene. This photograph was taken c. 1910, before the road was paved. In the foreground is the Oakland railroad station and immediately behind it is the Bush general store, which recently was the Wigwam and is now the McNally Engineering building. Notice the trees lining the road and the complete absence of cars and even horse-drawn buggies.

Making a delivery in his truck, Mr. Forshay (right) cruises up an unpaved Yawpo Avenue with a friend c. 1910. It is pretty clear that the men are not too concerned about either traffic or pedestrians, since the total population of Oakland was only about 568 at the time. In the background are the Bush general store (left) and the old Oakland railroad station (right).

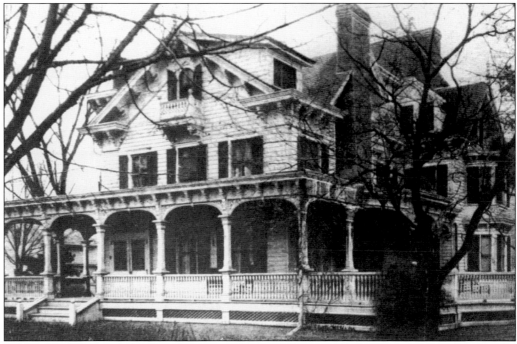

The Oakland Military Academy was originally the Calderwood Hotel, located on the site of the Grand Union shopping center. The building was purchased in the 1935 from the Calder family by Capt. John Scarca to be used as a military academy for 100 pupils from the third grade through high school levels. In 1961, he moved the academy to New York State. On August 21, 1962, the building was destroyed to make way for the shopping mall.

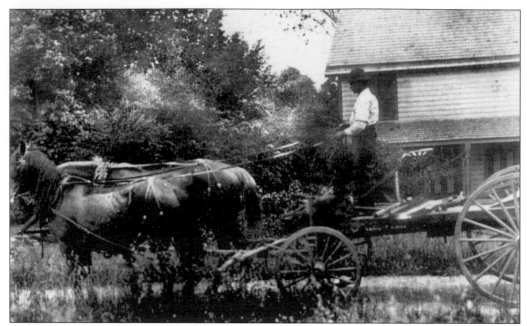

It is hard to believe that this photograph of a driver with his team of horses was taken on Ramapo Valley Road c. 1890. The location is identified as immediately south of the current police station.

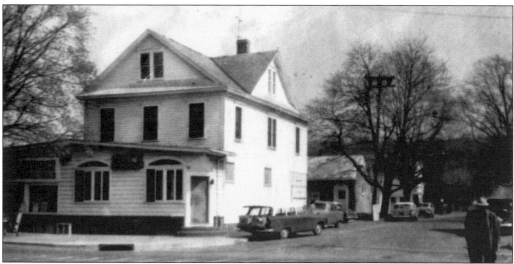

Located on the northeast corner of the Yawpo Avenue and Ramapo Valley Road intersection, Seel's Bar and Grill was a favorite watering hole of Oakland residents. Arthur J. Seel purchased the building in 1929, when it was the Oakland Hotel. In 1935, after running the hotel for six years, Seel converted it to a general store and a bar and grill. Before the advent of the current fire alarm system, a fire would be called in to the shop and Seel would leave to hand-ring the fire bell. Notice the store directly behind Seel's. It is now Pete and John's Paint Store. In 1957, Seel decided to demolish the building and build Oakland's first strip mall. Luminaries who frequently parked on the bar stools of Seel's Bar and Grill included playwright and Pulitzer Prize–winner Sidney Kingsley, his wife, Madge Evans, actress Norma Shearer, and American Civil Liberties Union cofounder Roger Baldwin.

Six

THE PONDS CHURCH

The founding of the Ponds Dutch Reformed Church in 1710 is a seminal event in the history and heritage of Oakland. Initially, it was a simple log structure. Next was a hexagonal stone church. A classic stone church followed on the original site and stood there until 1936. It is reported that George Washington knelt inside the church in prayer. Both the Declaration of Independence and the Emancipation Proclamation were read from the pulpit. The current structure, modified from the original Workhouse of God, erected in 1921, was built in 1960 and is the fourth Ponds Church building in Oakland, representing almost 300 years of continuous religious, social, and cultural contribution. The Ponds Church was here long before there was a United States, almost 70 years before George Washington rode through town. It was here during the area's great fires and floods. It is rightly said that today's Oakland is in part a reflection of the contribution of this church, its people, and its leadership within this community. Oakland continues to honor the Ponds Church. In 1936, during the Depression, the current library building was built as a replica of the 1829 Ponds Church and was dedicated as the Ponds Memorial Building. Further underscoring its contribution to Oakland is the fact that many of the stones used in the construction of the Ponds Memorial Building were taken from the rubble of the destroyed 1829 church.

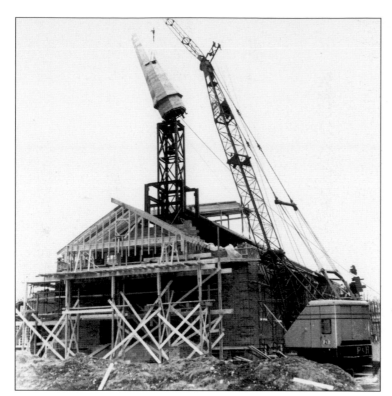

The spire is being raised on the current Ponds Church in 1960. The current structure is an expansion and complete renovation of the Workhouse of God, built in 1921.

The Ivy Society of the Ponds Church was a social organization promoting culture, religion, and occasionally but unsuccessfully, the evils of alcohol.

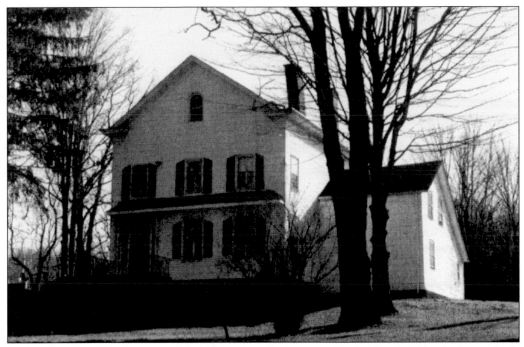

Located on Franklin Avenue, this is the original parsonage for the Ponds Church. It was built *c.* 1815 for the use of Rev. John Demarest as part of his compensation, along with 65 acres to farm and a $270 salary. Today, it is a private residence.

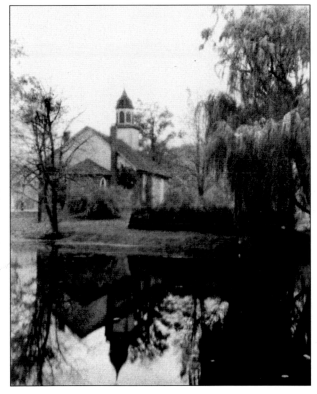

Originally, there was a pond behind the Ponds Church. The recess for the pulpit in the rear was added *c.* 1880 by Samuel Peter Demarest. Also, the original windows were rectangular with plain glass.

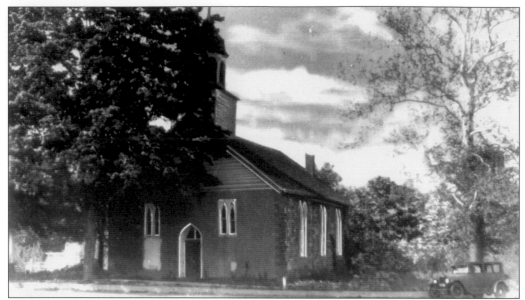

This building is actually the third Ponds Church building. It was erected in 1829 and served until 1936, when it was sold and razed. It originally had two doors and plain glass windows. The Portobello restaurant now occupies the site.

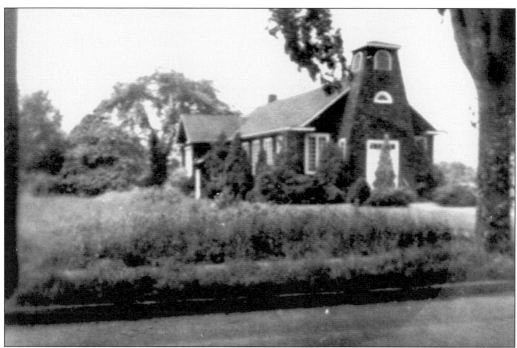

This is the fourth Ponds Church building constructed on this location. It was built in 1921 as the Workhouse of God. It is interesting to note that this was built to be closer to the center of town while the 1829 Ponds Church still existed for 15 years until its destruction in 1936. One can only speculate as to the reasons why it moved. Perhaps it was because services at the 1829 Ponds Church were disrupted by being sandwiched between Mullers Park and Pleasureland.

This particularly rare view of the 1829 Ponds Church reveals the building with two doors in the front and rectangular windows on the side. These features date the photograph to 1880 or earlier, as that was the year when a single door was installed and the windows were modified to Gothic style. Also, African American children are out front, revealing a very little known fact about Oakland: specifically, that there were many slaves in Oakland before and during the Civil War, tending the farms and homes of the primary landowners in town. The Emancipation Proclamation, issued by Pres. Abraham Lincoln and read from the pulpit of the Ponds Church in 1863, freed them.

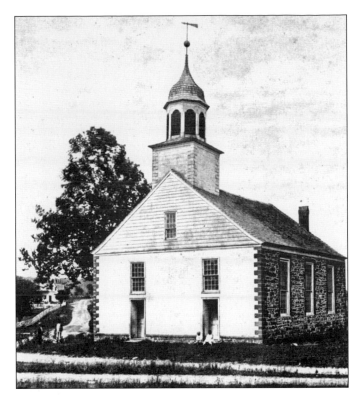

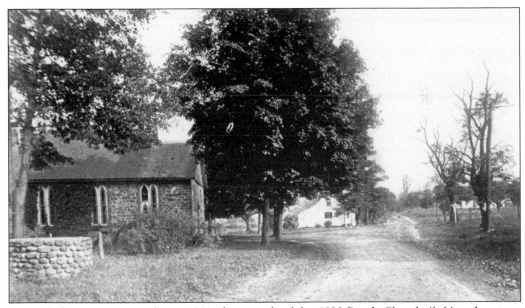

Particularly interesting in this *c.* 1900 photograph of the 1829 Ponds Church (left) is the view. It is looking east, roughly across from the present-day Burger King. The trail that continues straight ahead is Long Hill Road. The road turning the corner to the left is Ramapo Valley Road.

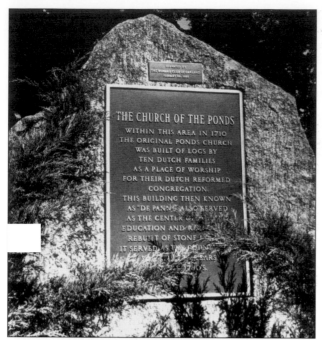

On February 20, 1960, the Oakland Woman's Club dedicated this memorial to the Ponds Church. It is located on the site of the original log Ponds Church, the hexagonal stone church, and the 1829 Ponds Church, on the corner of Ramapo Valley and Long Hill Roads. Its dedication coincided with the dedication of the current Ponds Church, located approximately one mile north on Ramapo Valley Road.

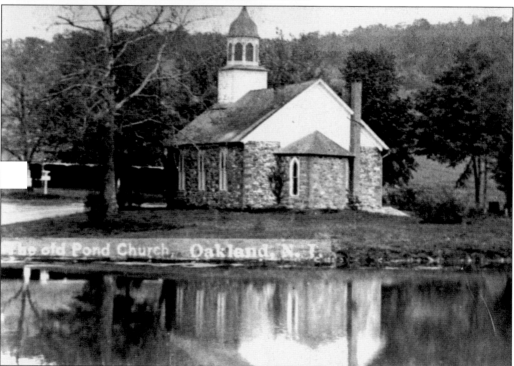

This 1829 view of Ponds Church shows the rear addition and the gothic windows that were added to the church by Samuel Peter Demarest c. 1880. It also shows the pond (now gone) immediately behind the church. Ramapo Valley Road is at the extreme left. A picture taken from the same spot today would require standing in the Portobello restaurant parking lot and looking across to the Burger King and the Shop Rite.

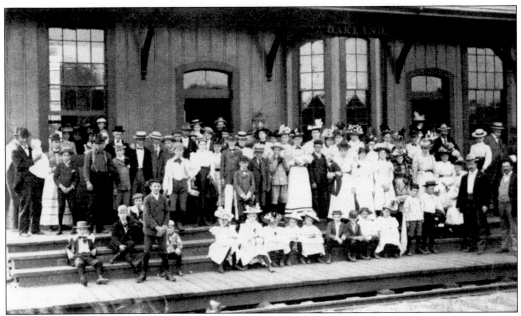

Members of the Ponds Church Sunday school turn out to travel by train to Echo Lake for a picnic on August 30, 1898. Almost 20 percent of the entire Oakland population is pictured here, waiting for the train in front of the old railroad station.

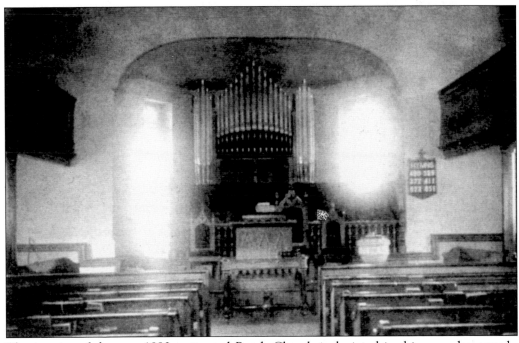

The interior of the post-1880 renovated Ponds Church is depicted in this rare photograph. The bright spots in the image are caused by the sunlight shinning through the windows of the section added in 1880. Notice the elevated sections on the right and left. At about this time the two church doors were removed and replaced by one and the individual family pews were removed.

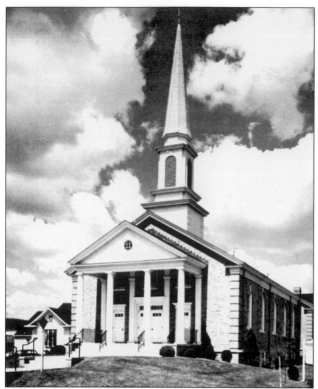

The new Ponds Church was dedicated in 1960. It was built at a right angle to the back of what used to be the 1921 Ponds Church Workhouse of God building (far left), thereby facing in the same direction as its three predecessors. The Ponds Church has served Oakland and its congregation continuously for almost 300 years. It not only left its mark upon this community but also in many ways defined Oakland during its early years and well into the 20th century.

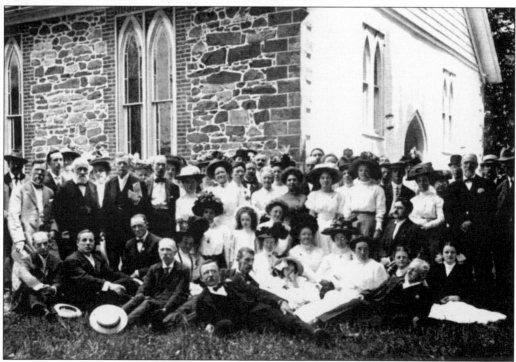

This rare photograph of the congregation of the Ponds Church was taken on June 6, 1909. Until the 1960s, the Ponds Church was the only house of worship in Oakland.

Seven
OAKLAND ON THE MOVE

This chapter focuses on transportation to and from Oakland throughout the last 134 years. Initially, this community was built around the location of the Ponds Church. In the Midwest, cities grew up and out from the river. In the East, they grew up around the railroad, and Oakland was not different. The center of town moved north one mile from the site of the Ponds Church building to the railroad station in 1869, when the New Jersey Midland Railroad came to town. In 1921, even the Ponds Church was moved north to the new town center. Route 208 came to Oakland in 1963, a few years after the railroad station was removed and passenger service discontinued. The highway permitted easy access to and from Oakland, thereby providing significant impetus for growth.

This photograph shows Phyllis Page (in the buggy) picking friends up at the Oakland train

station c. 1900.

Seen here is the 1871 Oakland train station as many current residents remember it. The photograph was taken in the mid 1950s, when Oakland had regular rail commuter service.

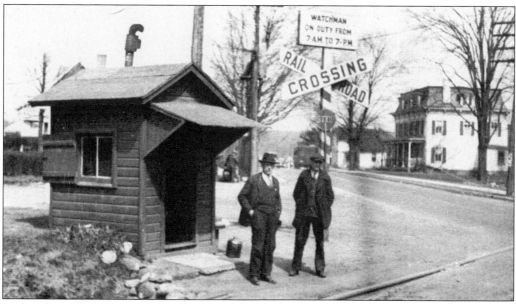

Railroad crossings were manned into the 1940s. Fred Alston (left), the signalman, stands with Jake Duryea, Oakland's first water superintendent, in the 1930s.

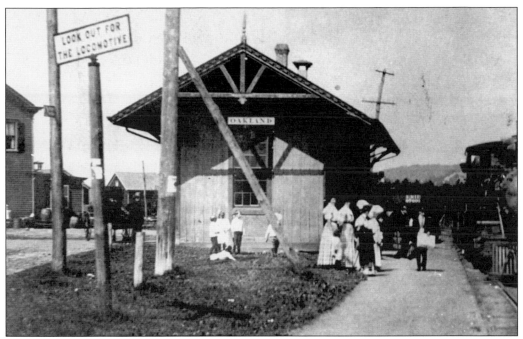

This wonderful picture shows people ready to board the Middletown mail train, which has just arrived at Oakland.

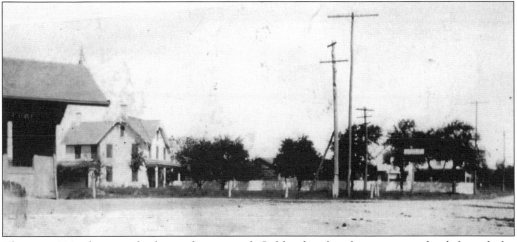

This *c.* 1920 photograph shows the original Oakland railroad station on the left and the Bush homestead immediately beyond it. It was taken looking north from the intersection of Yawpo Avenue and Ramapo Valley Road. The connection is that D.C. Bush was the first Oakland stationmaster before there was a station. He used his home as the ticket office from 1869 to 1871, when the Oakland railroad station was built. The presence of the electrical poles running north dates the photograph to after 1916, the year electricity came to Oakland, and the unpaved roads set the time prior to the mid-1920s, when Bergen County took control of road paving and maintenance.

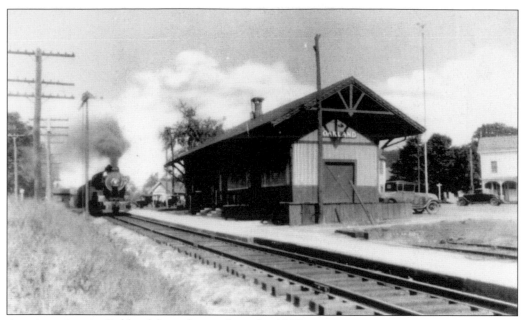

A train arrives in Oakland from the south in the 1920s.

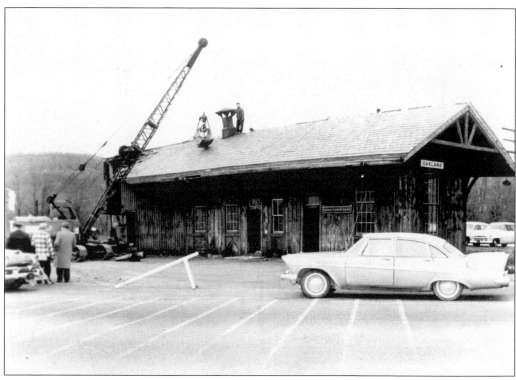

After serving the community since 1871, the Oakland railroad station was destroyed in 1962. It was replaced by a plain brick post office building, which was demolished in 1999.

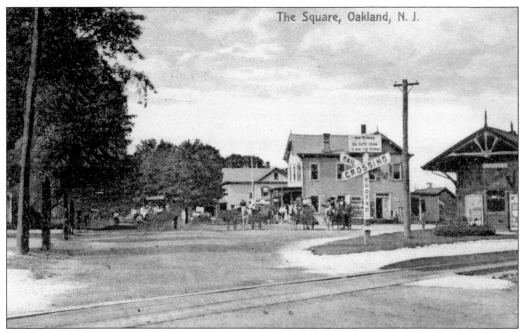

The Square, Oakland, N. J.

This may have been Oakland's first major traffic jam, as people and horse-drawn buggies vie and maneuver for space, without a policeman in sight, since Oakland had no police force at the time. The photograph was taken *c.* 1900 at the railroad station, apparently after the arrival of a passenger train. The travelers must have been eager to head home—in those days there was no other place to go in Oakland.

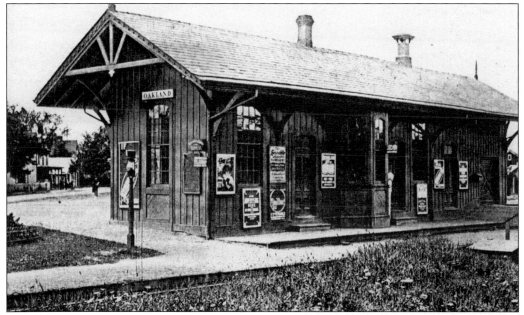

The railroad came to Oakland in 1869 at the height of the railroad wars in New Jersey. This photograph, taken *c.* 1915, is perhaps the best surviving picture of the old Oakland railroad station. A little-known fact is that it was built in 1871 by the people of Oakland. Exactly who paid for the construction and why the initiative was taken by the citizens is not known.

91

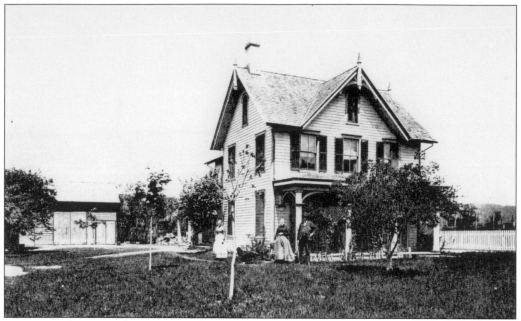

Shown is the home and railroad ticket office of D.C. Bush Sr., who is standing with his wife. The house was located across from the railroad station on the north side of the railroad tracks, on the corner of West Oakland Avenue.

From the 1930s comes this photograph of the current Bush plaza area. The monument in front is a memorial to the heroes of Oakland who served in World War I. Today, the pole and the concrete circle remain to recall the times represented by this scene.

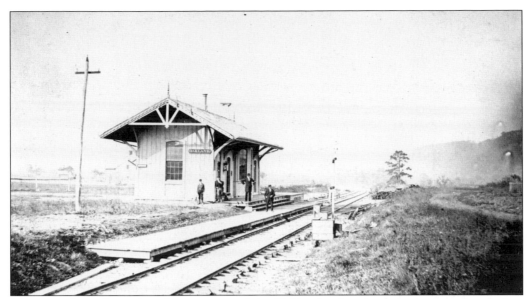

This is perhaps the earliest known view of the Oakland railroad station; it was taken before 1900. Notice that there were two sets of tracks, one of which terminated at the station. The stair structure across from the station was a device used literally to catch the Oakland mailbag from a moving train. The 1871 Oakland station also served as the post office, with D.C. Bush as postmaster.

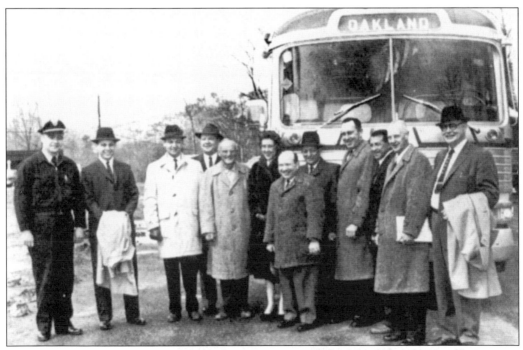

The loss of the train station and the rail commuter service harkened the advent of bus service from Oakland to New York City. This photograph presents the first scheduled bus trip to New York City, in April 1961. Mayor Al Potash, fifth from the left, stands among members of the council and chamber of commerce, in addition to a few lucky inaugural passengers.

The incline railroad was a unique resource of considerable engineering interest. Built in 1950 by Warner Rosenscheint, this cable-operated system climbed 200 feet up the side of a Ramapo mountain to the main house, at 19 Truman Boulevard. Clearly, Rosenscheint was a train buff. The line, however, was not connected to the full railroad. It was used to haul a large railroad car up and down the tracks to Rosenscheint's home atop of the hill. Subsequent owners have removed the tracks. It is the only known incline railroad to have operated in Bergen County.

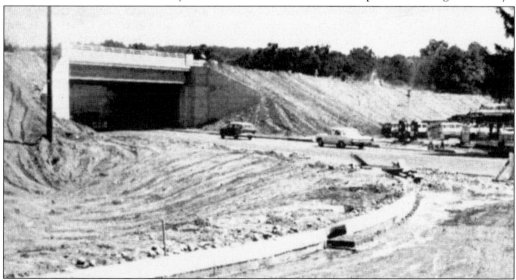

Shown is the construction of the southbound ramp of Route 208 from Ramapo Valley Road in 1962. The arrival of Route 208 brought access to the rest of the county and to New York City. Route 208 was planned and developed by the Work Projects Administration (WPA) during the Depression in the 1930s and was originally designed to go over the Ramapo Mountain and terminate at the Wanaque Reservoir. It never made its way to the reservoir, and it took 30 years to reach Oakland. Talk about slow!

Eight

OAKLAND AS A TOURIST TOWN

At the time of the Industrial Revolution, Oakland became renowned as a resort town. The rich and famous came and mingled with the masses. The abundant natural bodies of water became the recreation areas of choice for the workers in the textile town of Paterson and people as far east as New York City. Local Native Americans had referred to this area as the Ponds, undoubtedly due to the glacier lakes that existed here. The first beaches were areas on the shore of the Ramapo River and at the local lakes. Later, when pools were built, the Ramapo River was probably the source to keep these pools full and clean. During Oakland's resort boom days, there were at least seven public beach resorts and many more hotels. Even the pond behind the 1829 Ponds Church was a Fish-for-a-Fee commercial enterprise, where lucky anglers could catch brown and rainbow trout. Adjacent beaches extended along Ramapo Valley Road from West Oakland Avenue to the current Portobello restaurant. Thousands of people had plenty of fun at Oakland's resort facilities.

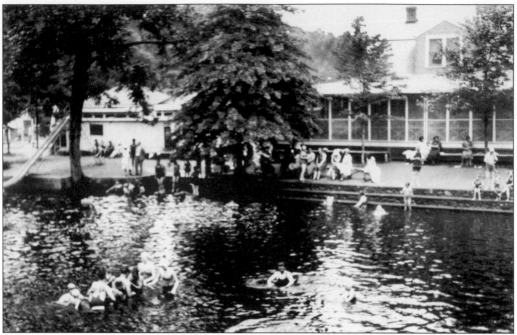

This c. 1930s photograph depicts vacationers enjoying themselves in the Ramapo River near today's West Oakland Avenue bridge. The building in the background was moved about 500 feet east, presumably to protect it from the rising storm waters, and later became the Timbers restaurant.

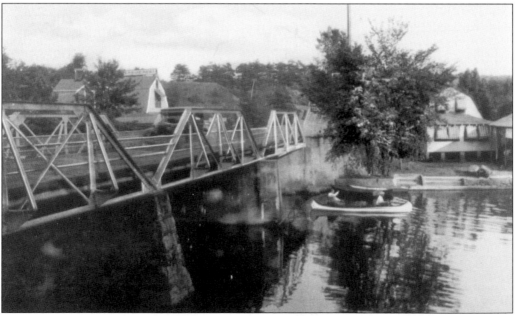

This is an "after" view of the area that was once the Riverside Rest. When pools became popular, swimming in the river became less common. The area was then reinvented and used as a center for canoeing and boating.

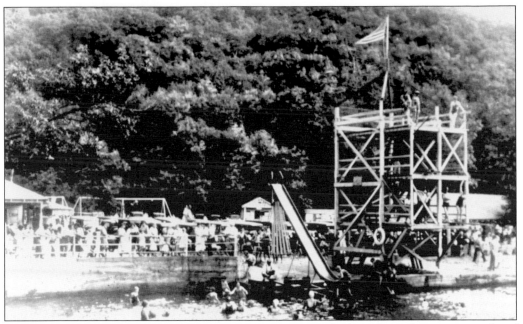

Sandy Beach was yet another Ramapo River swimming facility along the western side of town. In addition to swimming, Sandy Beach offered night bathing and free dancing as a competitive edge.

The sound of falling water and the spray in the air of these falls added to the attraction of the Sandy Beach facility.

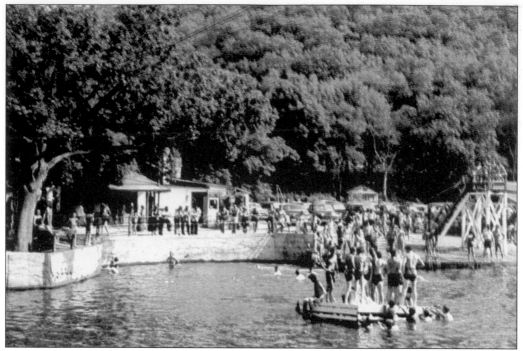

Seen here is Pleasureland Park *c.* 1950. Before 1932, Pleasureland did not have pools, as the Ramapo River was used for water recreation. However, that changed in 1950 with the addition of large swimming pools to the park's facilities.

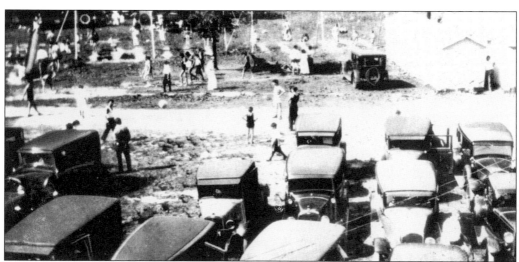

Although this photograph could be easily mistaken as a photograph of an Untouchables convention during Prohibition, it is really a scene of congested parking at Pleasureland during the 1930s.

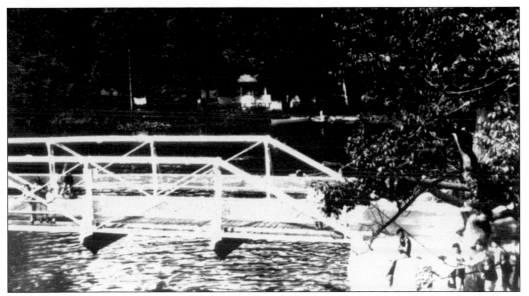

The Doty Bridge was the main road leading to Pleasureland from the north side of town. Pleasureland was located near this bridge.

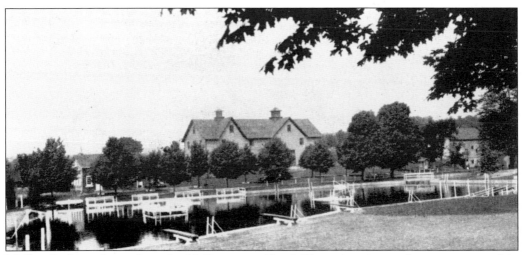

Mullers Park was located on the Muller tract of land. The swimming pool was constructed in 1932. In the background are the locker rooms. Previously, this building was a 24-stall stable.

Some vacationers preferred the calmness of the water in a lake setting, and for them there was Crystal Lake. Today, it is surrounded by homes.

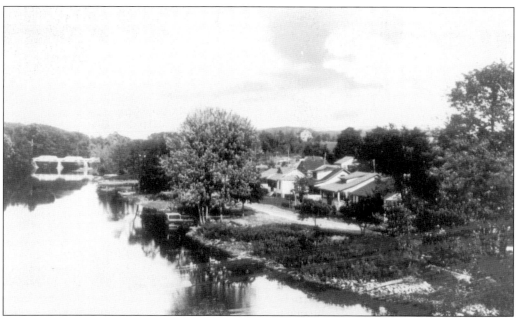

The use of the Ramapo River as a recreational asset took off after 1900. Seen here are a few of the many rental summer cottages along the east bank of the Ramapo River. Over time, they were winterized and converted into permanent homes.

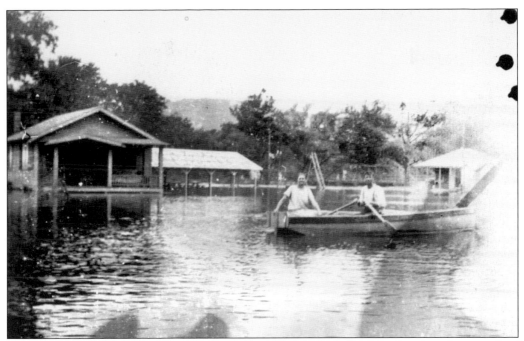

Being on the river brought the peril of occasional flooding, as illustrated in this photograph of Pleasureland during a flood in the 1940s.

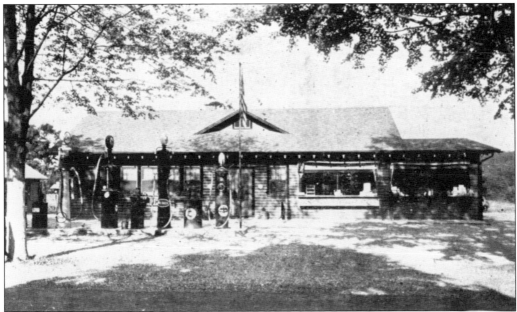

Ramapo Lodge, located on the southern section of Ramapo Valley Road above the river, began as a gas station and roadside refreshment stand, as seen here. However, during its prime, a full motel and cabins were built to accommodate Oakland's many summer tourists. It also had a full playground and zoo for the children. Today, this building is Hansels restaurant. The motel, the last of its genre in Oakland, lives on as the Ramapo Motel, a separate business entity.

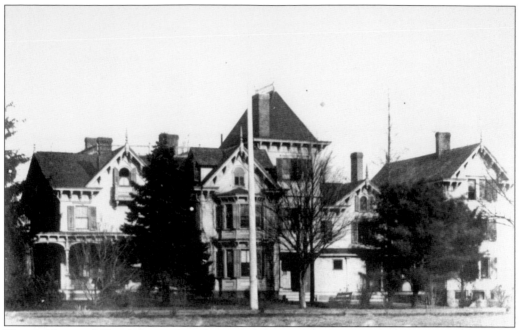

The Calderwood Hotel, located at the site of the current Copper Tree shopping mall, has a storied history. It was built as a summer house by the Calder family of New York City upon the ruins of a house built in the early 1800s by John Bush. After John Calder died in 1883, visiting friends urged his widow to rent rooms and serve meals. She did, and her residence became known as the Calderwood Hotel until 1935, when it was sold to become the Oakland Military Academy.

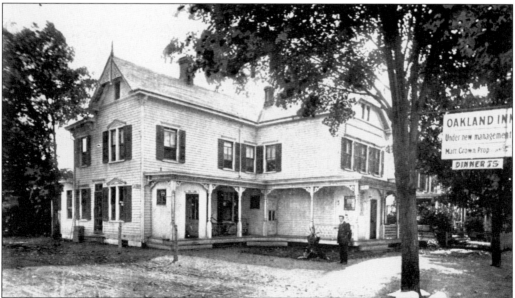

Before the Garden State Dairy Store and Krauszers, there was the Oakland Inn, pictured here prior to 1920. Located on the corner of Ramapo Valley Road and Yawpo Avenue, the Oakland Inn catered to the thousands of summer visitors, with rooms for rent and compete dinners for the princely sum of 75¢.

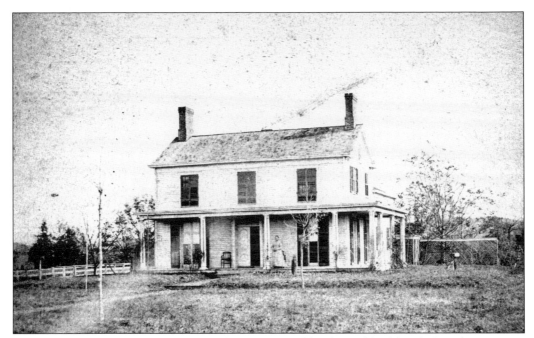

This vintage 1880s photograph shows the original Oakland Hotel building before there was an Oakland and before this building became a hotel. Located on the corner of Ramapo Valley Road and Yawpo Avenue, this building ultimately became a more substantial structure serving Oakland's vacationers. Art Seel bought it in 1929 and ran it as a hotel prior to converting it into Seel's Bar and Grill in 1935.

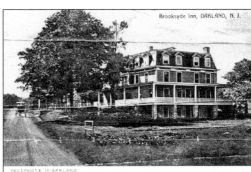

Although better photographs exist of the Brooksyde Inn, this flier contains the rarest view of them all. The early-1900s flier promotes the inn and provides directions from New York City. The reader is directed to take a ferry, since the George Washington Bridge, Route 4, Route 17, the Holland Tunnel, and the Lincoln Tunnel do not yet exist. The inn offered many luxurious features, including rooms lit with gas lamps, bathrooms on each floor with hot and cold running water, and fresh vegetables grown on the inn's own farm. Only the brook remains today, as the Brooksyde Inn no longer exists.

103

Current Oakland residents should easily be able to identify this building, as it has not changed much since the photograph was taken in the 1930s. Then, it was called the Cozy Grove. Today, it is the Valley Pub, a longtime favorite in Oakland. Originally, it was a restaurant and inn, renting rooms to the visitor, hunter, and patron unable to leave at closing.

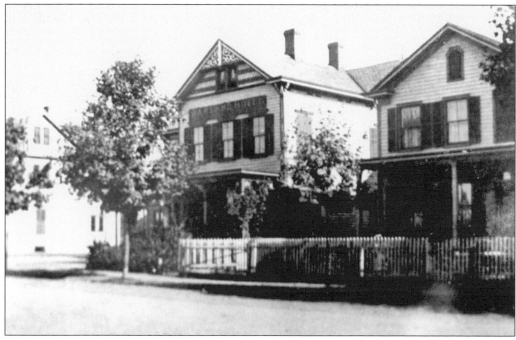

This is a second Oakland Hotel, sometimes referred to as the Hafel Hotel. Located on the southeast corner of Ramapo Valley Road and Yawpo Avenue, the hotel later became the Oakland Inn. Krauszers food market now stands in its place. For a short time before Oakland became an independent community, the building also served as the Oakland post office. This photograph was taken c. 1890.

104

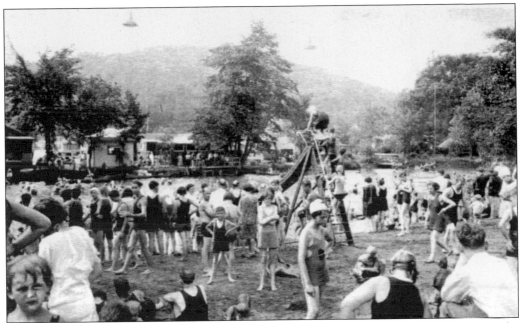

Everyone except the unidentified child in the lower left of this 1920s photograph seems to be having a good time at White Birch Park. This swimming and picnic area was one of nine such facilities along the Ramapo River that were open to the public during the tourist heyday of Oakland. The other eight were Crystal Lake, Riverside Rest, Oakland Beach, Sandy Beach, Mullers Park, White Birch Beach, Klein's Beach, and Pleasureland. Pleasureland, the last remaining facility, closed following a violent incident in 1985.

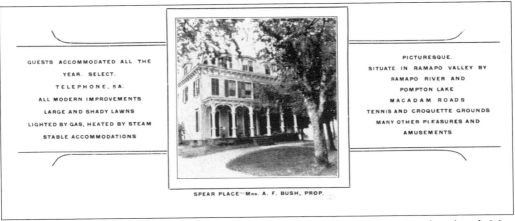

GUESTS ACCOMMODATED ALL THE
YEAR. SELECT.
TELEPHONE, 5A.
ALL MODERN IMPROVEMENTS
LARGE AND SHADY LAWNS
LIGHTED BY GAS, HEATED BY STEAM
STABLE ACCOMMODATIONS

PICTURESQUE.
SITUATE IN RAMAPO VALLEY BY
RAMAPO RIVER AND
POMPTON LAKE
MACADAM ROADS
TENNIS AND CROQUETTE GROUNDS
MANY OTHER PLEASURES AND
AMUSEMENTS

SPEAR PLACE—Mrs. A. F. BUSH, PROP.

This is a copy of a rare, original promotion leaflet for Spear Palace, a luxurious hotel with Mrs. A.F. Bush as proprietor. It is interesting that two very famous Oakland families, Bush and Spear, were part of this endeavor. Originally the ancestral home of the Spear family, the hotel was located on the southern part of Ramapo Valley Road immediately north of the current Dairy Queen. Eventually, it became the Oakland Jewish Community Center, and ultimately, it was destroyed to build a synagogue in its place. Today, the synagogue is gone, and its building serves as a school for talented children. (Courtesy of Frank Leone, Oakland postmaster.)

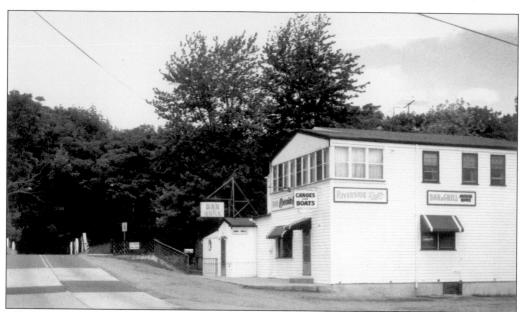

Shown above is the Riverside Rest, located on the bank of the Ramapo River, after the bathing and swimming era. It has become a bar and grill, limiting its recreational activities to canoe rentals. Because of persistent flooding of the Ramapo River, the entire building was moved a few hundred feet east on West Oakland Avenue to its present location. Eventually, it became Kermits Pond restaurant, and it is the Timbers restaurant today.

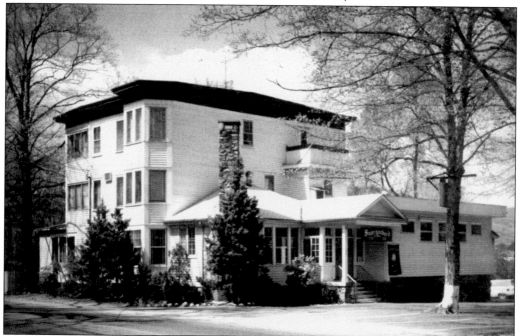

Few people would remember that the Hansen House restaurant was the original restaurant on the site of the 1829 Ponds Church. Even fewer people would know that the building was originally a private home. After the Hansen House, it became Molly's fish market, and today it is the Portobello restaurant.

Nine

SERVING OAKLAND WITH PRIDE AND DISTINCTION

We honor here those who served Oakland in the past, and we dedicate this chapter to those who serve now and in the future: the police and fire departments, the library, the ambulance corps, the post office, the public works department, and all others who selflessly serve the community. Each of these organizations ranks as among the best in New Jersey. We have attempted to recall a bit of the past of each, to remember how it was during a different time, and to reflect upon today's public service excellence.

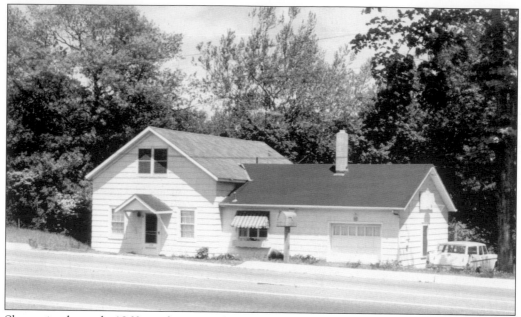

Shown in the early 1960s is the original one-room schoolhouse after it was developed into a private home. The building was located on the north side of Route 208 on the approach to the Oakland exit for Ramapo Valley Road northbound. It was demolished to accommodate the development of Route 287.

Dorothy Johnson's eighth-grade class poses before graduating from Oakland Public School No. 1 in 1922. From left to right are the following: (front row) Barrett Boone, Grace Hopper, Dorothy Johnson, Gladys Hanford, Gertrude Trofler, Marie Terhune, David Burns, and Ward McLaughlin; (back row) Joseph Madunio, William Boone, William Gneir, Clarence Skutt (principal), Walter Trofler, James Andioris, Helen Labaugh, and Minnie Van Houten.

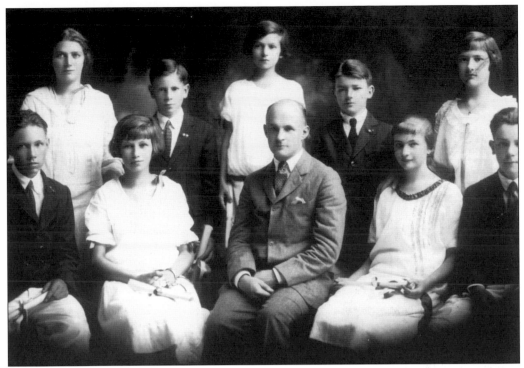

Members of the 1923 graduating class of the Oakland Public School No. 1 are, from left to right, as follows: (front row) Henry Keyser, Milford Carlough, Clarence Skutt (principal), Grace Sachse, and Michael Gneir; (back row) Ruth Courter, John Waldron, Esther Hopper, Gregory ?, and Eleanor Terhune.

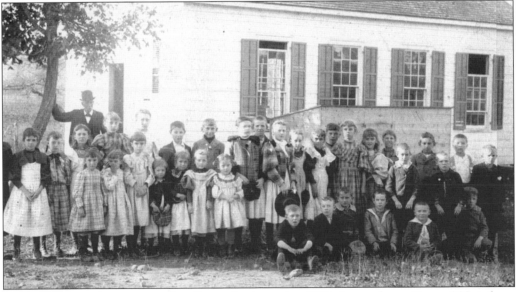

Oakland's original one-room schoolhouse is pictured c. 1903. Located near Route 208, it later became a private residence, which was demolished with the creation of Route 287. It was the Wyckoff section's decision not to build a better schoolhouse that led Oakland to form its own borough in 1902.

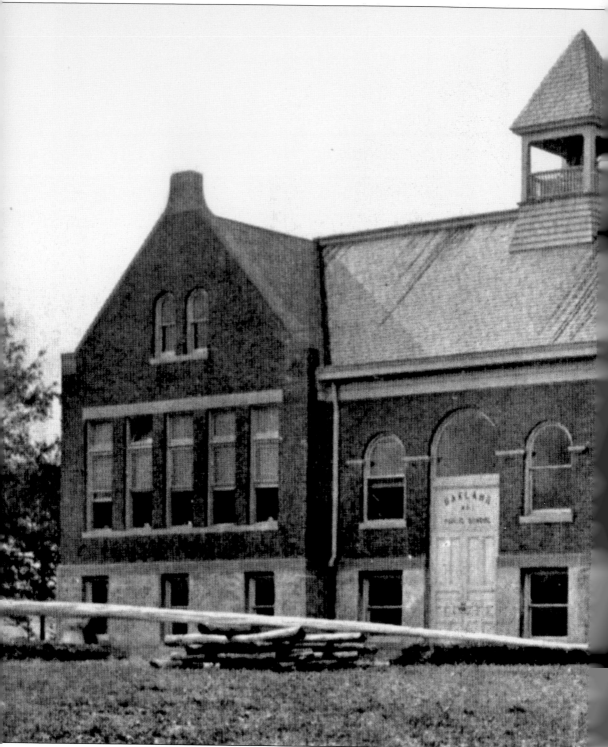

This is the earliest known photograph of the Oakland Public School No. 1 still under construction. Built in 1907 for the sum of $13,500, the school was originally budgeted

at $10,000. The actual cost reflects a construction overrun of 35 percent. Some things never change.

The Oakland Public School No. 1 (right) is pictured from Ramapo Valley Road *c.* 1915. Ivy Hall (left) was then the Oakland municipal building.

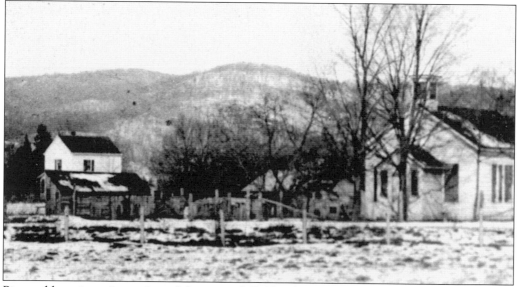

Pictured here is a winter view of the original Oakland one-room schoolhouse (right) *c.* 1903.

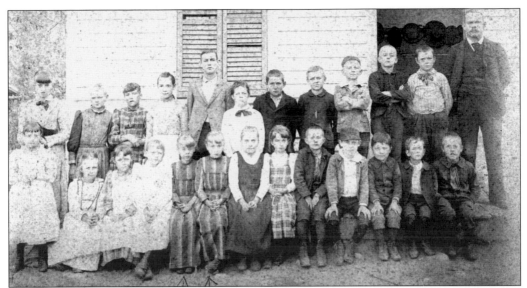

Shown is the community's entire school population *c.* 1890, before Oakland seceded from Franklin Township. Children of all ages in all grades were all taught in the same room by the same teacher.

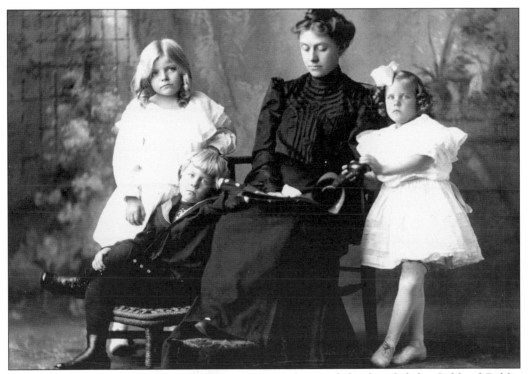

Louise Sheffield poses with her class. She was a teacher, and she founded the Oakland Public Library in 1900. She initially housed the library in her home and lent books to both children and adults. Her husband, Charles Sheffield, was president of the board of education and instrumental in getting the Valley School No. 1 built in 1907. He also was a member of the borough council and the board of health.

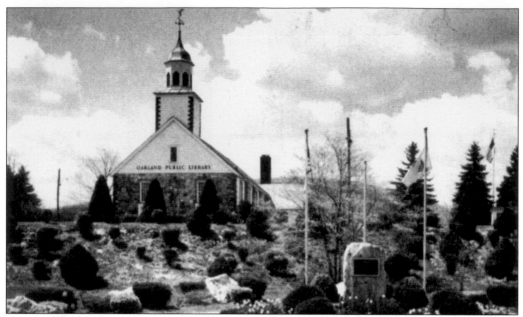

The Ponds Memorial Building is the sixth home of the Oakland Public Library, according to handwritten notes by H.R. Hopper, a founder of Oakland. Dedicated on July 17, 1937, the new municipal building was constructed to resemble the 1829 Ponds Church. The library moved into this building in 1962 and is currently undergoing a major expansion.

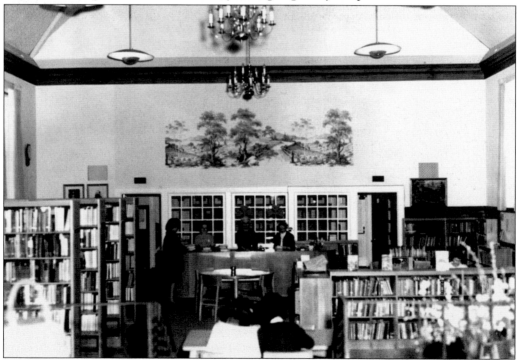

This interior view of the Oakland Public Library was taken just before St. Patrick's Day in the early 1960s. Since then, an upper level tier of bookstacks has been added and the basement—which used to house a bowling alley—has been converted to a children's library.

The Ponds Memorial Building was built in 1932 during the Depression era. This mural, painted by Giorgi Manuilov as a Works Progress Administration project, depicts the purchase of about 5,500 acres around Oakland by a Dutch businessman from the Minisi Indians. It does not take much to figure out who got the better part of the deal.

This is one of the many homes of the Oakland post office, on Ramapo Valley Road. The picture was taken during the mid 1950s. This building is easily recognizable and still exists as a baseball memorabilia retail store. There are 48 stars on the flag seen here.

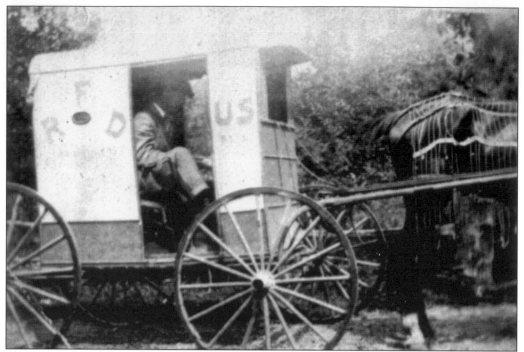

Postman Steve Jackson makes his delivery rounds *c.* 1900 in Oakland. A sign of the times, the RFD on the side of the buggy stood for "rural free delivery"—an accurate moniker, since the total population was 500 people who lived essentially on the four or five streets in existence then.

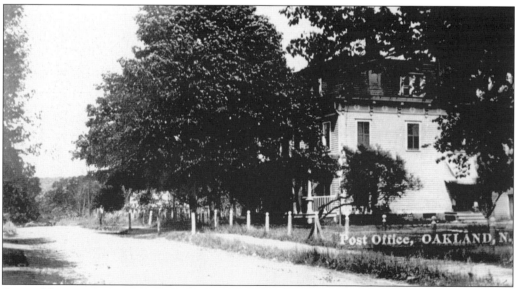

Annie Meyer was a very active woman in early Oakland. Her home was used as the Oakland post office and was probably the first of several post office locations in Oakland. Her home still exists and is used as a professional building.

116

Two events occurred at about the same time: first, the railroad decided to demolish the old Oakland railroad station, and then the Oakland post office outgrew its location. The result is the "new" Oakland post office (above), built in 1962. However, Oakland's growth quickly made this building obsolete. It was turned back to Oakland for cultural, recreational, and health uses. The building was recently demolished, leaving an empty space, as had existed in 1871, prior to the building of the original train station.

You might recognize this building as the current Oakland post office. However, did you know that it was an A & P prior to its present incarnation as the "new" post office?

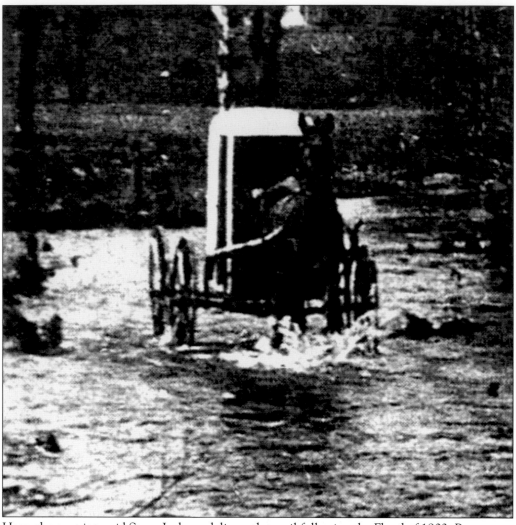

Here, the ever intrepid Steve Jackson delivers the mail following the Flood of 1903. Postmaster Frank Leone and his capable post office staff continue the tradition today.

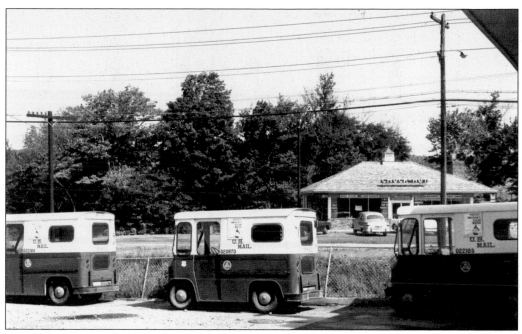

Remember these? They are the post office delivery trucks parked behind the 1960s Oakland post office, adjacent to the railroad tracks. Notice the Chuck Hut across the tracks on West Oakland Avenue. Its window sign advertises a turkey dinner for $1 and invites patrons to enjoy their featured air conditioning. That building is currently Tony's Brothers Pizza & Restaurant.

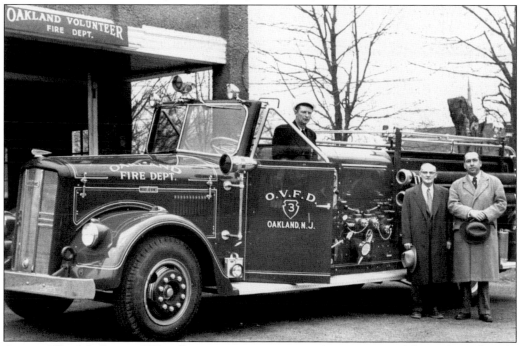

A new Ward LaFrance 750-gallon-per-minute pumper fire engine is delivered to the old Oakland firehouse in 1954. Present for its delivery, from left to right, are Chief Dennis Clark, Mayor Al Potash, and Robert Walker.

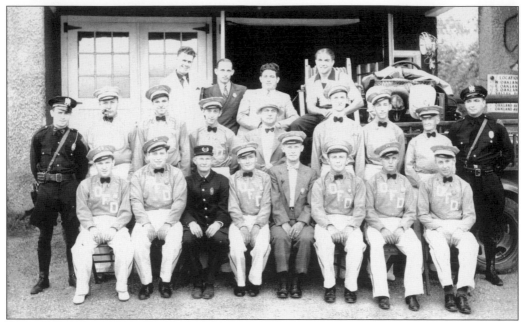

The men and women of Oakland have always been involved in the fire department. This photograph of the Oakland Fire Department *c.* 1940 shows the depth of involvement of the community, which then numbered about 600 residents. From left to right are the following: (front row) Harold E. Munn, Ben Otto, Henry Hopper, unidentified, Harry Gail McNomee, Ted Eve, Charles Pomsky, and Bill Rogers; (middle row) Officer "Lefty" Melville, two unidentified people, Ed Hanney, Reverend Stoneton of the Ponds Church, Harold Johnson, Mario Polla, Harry Coin, and unidentified; (back row) John Melville, Louis Ringa, Frank Capalouso, and unidentified.

Henry Hopper was a founding member and president of the Oakland Fire Department in 1909. Part of the stimulus for the organization of the Oakland Fire Department at that time was a fire at the barn of the Calder residence (the Calderwood Hotel) in 1903.

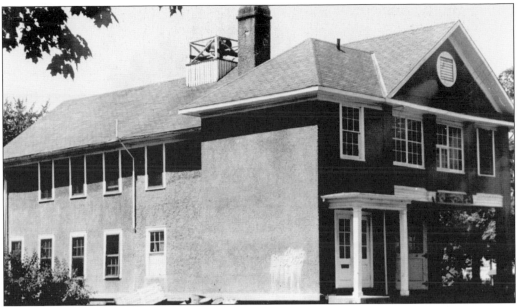

This is the original Oakland firehouse, built by Gideon DeWitt following the incorporation of the fire department by the borough in December 1911. This classic firehouse was located on the south side of Yawpo Avenue across from the current firehouse and approximately where the current Valley National Bank is situated. It served Oakland well and was functioning into the 1960s. During that period, it functioned as the Oakland Public Library, the borough hall, and a community center.

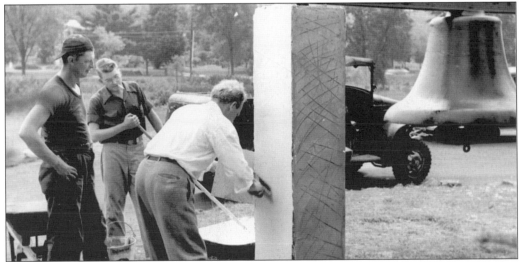

This Oakland Fire Department bell has a bit of its own history. Here, it is being reinstalled in 1952 as part of Oakland's 50th anniversary celebration. It was originally purchased through the fund-raising efforts of the Oakland Fire Department Ladies Auxiliary. However, because it weighed 1,280 pounds, it was far too heavy for installation atop the firehouse. Until 1925, it was suspended and rang from heavy wood beams in front of the Oakland train station. In that year, it was officially retired but remained in place when electric sirens were installed at the old firehouse. After being neglected for 16 years on the side of the Ponds Memorial Building, it was resurrected and, in 1952, became a permanent memorial dedicated to Oakland's finest.

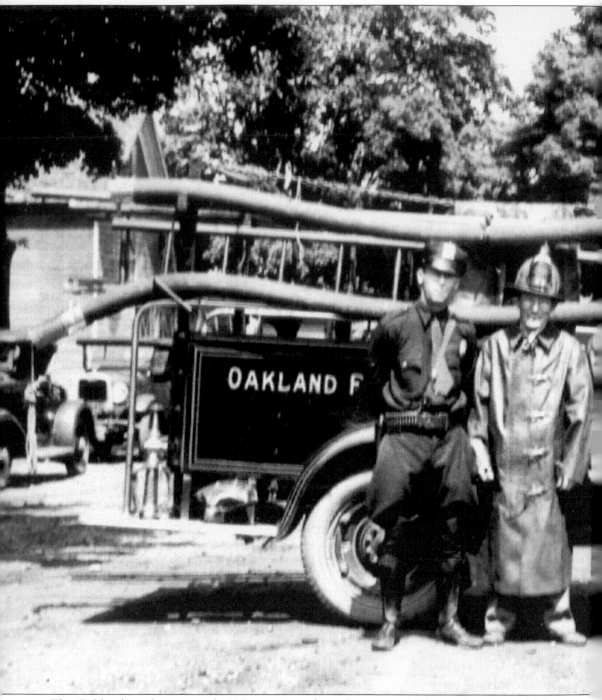

The Oakland smoke-eaters of 1935 are pictured on the corner of Yawpo Avenue and Vine Street (now Raritan Avenue). From left to right are policeman Harry Melville, firemen Al

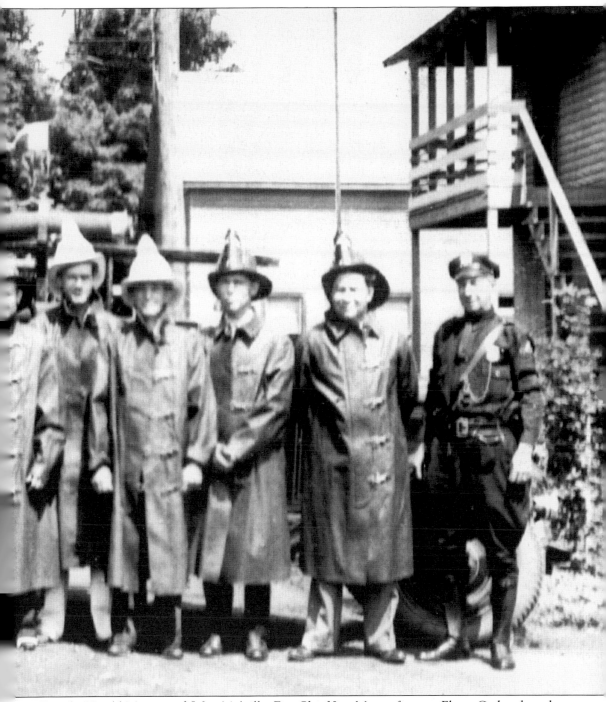

Potash, Harold Munn, and John Melville, Fire Chief Jim Munn, firemen Elmer Carlough and Ben Otto, and policeman Harry Farrel.

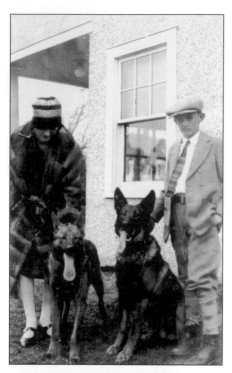

Shown are Al Sanders (right) and his good dog Flash next to the old firehouse *c. 1930*. Sanders, a lifelong resident of Oakland currently living on Grove Street, went on to become an Oakland volunteer fireman for many years. The woman on the left is his sister, Hazel. Flash had a sad demise. After making a trip to and from Florida on the running board of the family car, he was hit by a car in Oakland.

You've come a long way, Baby. A very early addition to Oakland's firefighting equipment is set in contrast to a modern ladder engine. The original firefighting equipment was a four-wheeled, hand-and-horse-drawn 50-gallon chemical tank, which held a soda acid solution. It was purchased for the princely sum $210. This was augmented by a 1910 Chalmers automobile, donated to the Oakland Fire Department by Mrs. Remington Vernam.

Taken prior to 1936, this photograph shows the original Oakland fire-alarm bell mounted on wood posts with the old Oakland firehouse in the background. The photograph is taken from the parking lot of the Oakland railroad station looking east to the firehouse on Yawpo Avenue.

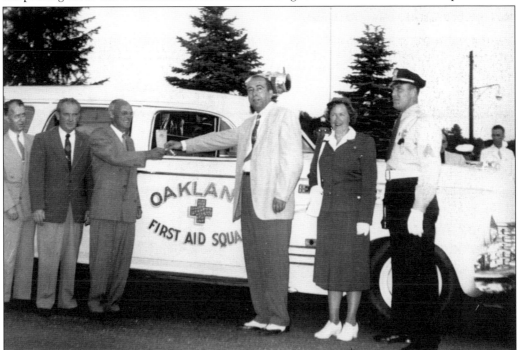

The Oakland First Aid Squad was formed in 1954 with the donation of an ambulance by John Walker. From left to right are unidentified, Harold J. Munn, Mayor Al Potash, John Walker and his wife, Vivian Walker, and Sgt. Joe Woods. John Walker was a councilman and president of the council. Vivian Walker was equally involved in Oakland affairs, serving on the library board and the board of education. She was named Woman of the Year by the Woman's Club. She still lives in Oakland, residing on Grove Street with her daughter.

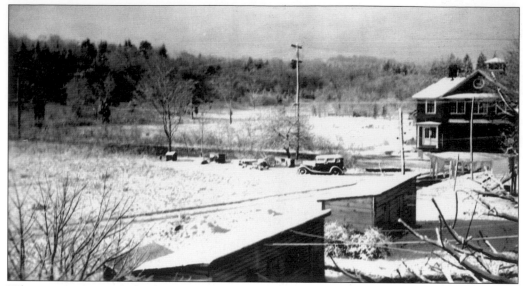

What is interesting about this photograph, in addition to the old firehouse on Yawpo Avenue, is its familiar location. Shown here from Al Sander's backyard (located at the site of the strip mall adjacent to the railroad tracks) is the original location of the firehouse in what is now the Copper Tree shopping center parking lot, which was built 30 years later in the field shown in the upper left corner of the photograph.

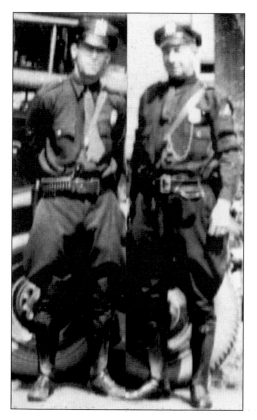

Patrolmen "Lefty" Harry Melville (left) and Harry Farrel are shown in this 1935 photograph, taken 22 years before the Oakland Police Department was formally organized in 1957. The current chief, James O'Connor, was the 12th patrolman to join the Oakland police force. He joined in 1966.

The Oakland Police Department was formally organized in 1957 as a full-time organization. This is a photograph of an Oakland marshal badge from the 1920s. Prior to 1957, if it was after 5:00 p.m., an Oakland citizen was required to call the Pompton Lakes police to report an incident. The Pompton Lakes police would then call the Oakland policemen at home to respond.

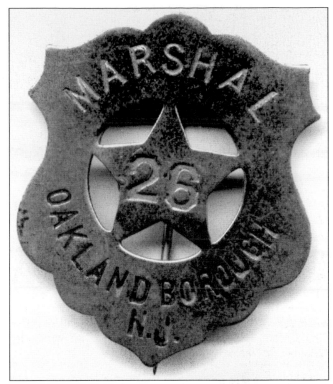

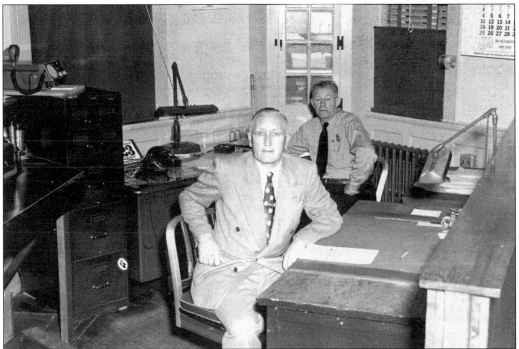

Seen here is the Oakland police headquarters in October 1953. John Pauls, an Oakland councilman, is in the foreground. Behind him is Chief Les Marrion. Note the then-state-of-the-art communications equipment on top of the file cabinet.

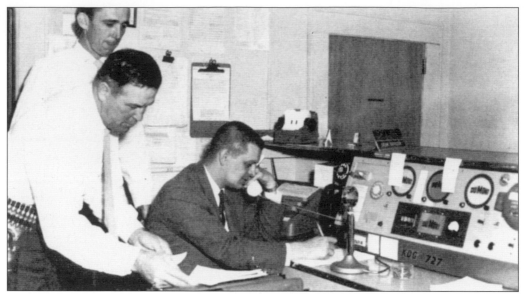

As Oakland grew in the 1950s and 1960s, so did the police department. In this 1964 police headquarters scene, the latest communications equipment console includes two telephones, a two-way radio, and a typewriter. In the left foreground is Chief Joe Woods, an outstanding chief of police and a colorful figure. He typically carried a pearl-handled pistol and silver bullets, as seen here. Seated at the console is Sergeant Hasenbalg, and standing is Lt. Joseph Eilert.

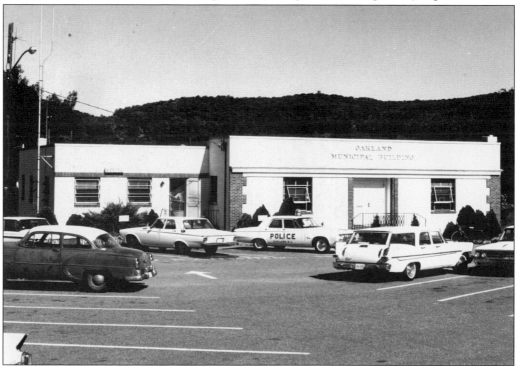

This 1961 photograph illustrates that for many years the Oakland Police Department headquarters was located in a wing of the current municipal building. The new and present police headquarters was built in 1978.